ANYTHING IS POSSIBLE

ANYTHING IS POSSIBLE

MARY ANN WINGFIELD

First published in Great Britain in 2020 by MAW Designs Ltd

Edited, designed and produced by Tandem Publishing
http://tandempublishing.yolasite.com

ISBN: 978-1-5272-6989-7

10 9 8 7 6 5 4 3 2 1

A CIP catalogue record for this book is available from the British Library.

Printed and bound in Great Britain by CPI Group (UK) Ltd, Croydon CR0 4YY

'Keep away from people who try to belittle your ambitions. Small people always do that, but the really great make you feel that you, too, can somehow become great.'

– Mark Twain

Contents

The Lion's Share

In which I introduce myself

Leos, according to Linda Goodman, the late American horoscope writer, are 'fun, friendly and warm people with sunny smiles'. She is probably right. Leos who are angry or deeply upset, however, can, with one look, freeze the marble off the Elgins, adding a whole new dimension to the word 'cold'.

This Leo was born on 12 August 1937, in a Sussex cottage hospital. She arrived at 9.30am, weighing 6lbs 4oz. A somewhat disappointing result, I fear, compared to the more robust weight of modern babies.

For the first two years of my life I had the attentions of Nanny all to myself. It was she who, no doubt prodded into action by my mother, noted my daily doings in a book that I have to this day. Nanny was observant. The book might have made dull reading were it not for the fact that

she recorded a great deal of what was going on in ordinary homes in the build-up to the Second World War.

For a couple in their twenties, dependent on my father's salary of £90 per annum at ICI (the company he joined in 1933) plus a small parental allowance, life before the War was comfortable. As well as Nanny, my parents were able to employ a cook, a housemaid and a gardener/chauffeur. (The same quality of life was certainly not available to a young couple dependent on a husband's salary when I got married in 1961, despite the fact that my husband's pay was also boosted by a small parental allowance.)

When inflation took a stranglehold in August 1939, my parents' lifestyle changed. The Chancellor of the Exchequer, Sir John Simon, introduced his War Budget to the House of Commons on 27 September, announcing that income tax was to be increased from 5/6 to 7/6 in the pound, the highest rate ever reached in this country. It meant that now more than 10 million people were paying direct tax.

Family

My father's father Sir Gerald Wollaston,[*] who was born in 1874, was still Garter Principal King of Arms when I was born. In 1902 he had followed his maternal grandfather, Sir Albert Woods, and his great-grandfather, Sir William Woods, into the College of Arms. All three men attained the position of Garter Principal King of Arms, the highest office in the College.

The College of Arms, sometimes referred to as the College of Heralds, was founded in 1484 and has since then created and maintained official registers of Coats of Arms and pedigrees. The heralds who make up the College are members of the Royal Household and act under Crown Authority. The Garter Principal King of Arms is the most senior King of Arms (there are three).

[*] Sir Gerald Woods Wollaston KCB KCVO, born 2 June 1874; died 4 March 1957.

3

This record, whilst not equalled by any other family so far, might have been even more impressive and included *four* consecutive generations had not my great-great-uncle Bertie Woods left the College of Arms after he threw a man down the college steps for saying that his grandfather and his father were illegitimate.

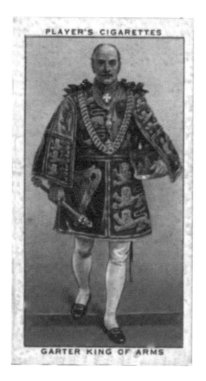

The poor victim of Bertie Woods' assault had a fair point, for Sir William Woods had been born under, if not a gooseberry bush, then most mysterious circumstances. He also had a cavalier attitude towards his own marriages – or lack of them – even by the standards of his day. This meant that

his six children, by two different women, were all illegitimate. An awkward situation, you might think, for a man in charge of genealogy.

It was my grandfather who took the young 16th Duke of Norfolk under his wing in 1929 and helped him to acquire detailed knowledge of the ceremonial duties connected with the Duke's role of Earl Marshal. Thereafter, they worked closely together, surviving the bumpy ride over the abdication of Edward VIII in 1936, and organising the Coronation of his brother, George VI, in 1937.

Throughout this period my grandmother frequently addressed her husband as Garter; in fact, it was many years before I realised that he had any other name. We children called him Grandpa, adding his surname when we wanted to differentiate him from Grandpa Gilbert, my mother's father. Granny Wollaston was always Granny since Grandpa Gilbert had been widowed the year after I was born.

Grandpa Gilbert was as tall as Grandpa Wollaston was small. He was wafer-thin and with his aquiline features and ash-blond hair, which turned silver as he got older, very distinguished-looking. An athletic man, and a good swimmer, he had originally wanted to join the Navy, but maternal pressure steered him towards Cambridge and the Church.

When I was born in 1937, Grandpa Gilbert was the vicar at Groombridge in Sussex, where he remained until he retired to the College of St Barnabas, a home for clergymen at Lingfield, Surrey, in 1957. Granny Gilbert died on 29 April 1939 as the indirect result of a car accident. My grandfather

had been driving at the time and my mother never forgave him for 'killing' her mother. This seemed slightly unfair as Granny Gilbert's demise was not an immediate result of the accident. Rather, she died some months afterwards, but my mother blamed my grandfather anyway.

My grandmother Gilbert had been born Lydia Grace Barton, the only child of Walter Barton, a corn merchant and his city-loving wife. They were a couple who seemed to be estranged in almost everything but name.

My grandmother Wollaston, on the other hand, came from very tough Irish stock. She was the eldest daughter of Sir Robert Alfred McCall, who was born in Lisburn on 9 July 1849. He, in turn, was the third son of Hugh McCall, the historian and journalist from whom, perhaps, I inherit both my interests.

My great-grandfather, Robert McCall, whom I never knew since he died in 1934, was educated at Queen's College, Belfast, and at Queen's College, Galway, and was called to the Bar by the Middle Temple in 1871. Thereafter, he joined the Northern Circuit* and took Silk in 1891. He became one of the most sought-after common law counsels of his day, which is perhaps not surprising since he had had a great early mentor in Sir Henry James, later Lord James of Hereford, the Liberal Unionist to whom he had been briefed.

In 1876 Robert McCall married Alice MacSwinney, the daughter of James MacSwinney of Galway. It is from her

* The Northern Circuit dates from 1176 when King Henry II sent his judges out on circuit to hold court and do justice in his name.

that various family members have inherited their red hair, although her eldest daughter, Olive, my grandmother, did not. I have a painted miniature of my great-grandmother with an abundance of russet-coloured hair piled on top of her head.

Between 1899 and 1921 Robert McCall was Attorney General. He was also Queen's Sergeant to the Duchy of Lancaster, an appointment he held until his death. He was knighted in 1921.

A founder and a staunch supporter of the Ulster Association in London, his legacy has lived on after him in the form of the Spy cartoon entitled 'Ulsterman KC',* launched by *Vanity Fair* magazine in November 1903, a much sought-after collector's item in the 21st century.

* KC stands for King's Counsel. QC for Queen's Counsel if the reigning monarch is female.

He died on 6 April 1934, aged eighty-four. The funeral was at St Luke's Church in Redcliffe Square, London and he is buried at Kensington Borough Cemetery in Hanwell.

My great-grandmother became slightly eccentric in her elderly widowhood. She was apt to arrange to stay for a period with members of her family, have a little rest on her arrival and then, on waking up, go downstairs and call for her car to leave just as the family was staggering up to her bedroom with her luggage.

My great-grandmother, Alice McCall. Her earrings are made of bog oak and in the middle, cast in 22-carat gold, are tiny Irish harps.

War Drums

B y the beginning of 1939 the drums of war were beating ominously and the 'golden life' began to wind down.

On 27 April 1939 conscription was introduced in Great Britain and my father, who was already a member of the Territorial Army, duly enlisted. He was made a Second Lieutenant in the 4th Battalion of the Queen's Own Royal West Kent Regiment on 18 July 1939, but in a glorious oversight his commission was never issued.

With the survival of himself and his family uppermost in his mind I do not imagine this bothered him too much, but the omission has an interesting sequel. In October 1996 the Ministry of Defence sent a letter to my father, four months *after* his death, apologising for being fifty-seven years late in sending his commission and wondering whether, even at this stage, he would like to receive it? A clear case, at least in their eyes, of better late than never.

For reasons which I have never been able to fathom, whilst commissioned into the 4th Battalion my father served with the 5th Battalion during the three years, he was with the Queen's Own Royal West Kent Regiment.

On 3 September 1939, war was declared between Britain and Germany and compulsory military service came into force for all men aged between eighteen and forty-one. On the same date an evacuation scheme was put together to move 1,200,000 people away from perceived danger spots to the relative safety of the countryside.

My father's battalion was stationed at Maidstone in Kent but evacuation for his family at that time was not an option. My mother was already pregnant with my sister, Ione, who was not born until 26 October 1939. By this date, a German U-boat had already sunk HMS *Royal Oak* in Scapa Flow,[*] an event which signalled that the War was well and truly underway.

After the birth of my sister my mother contracted puerperal fever,[†] so evacuation remained out of the question as she was far too ill to travel.

The 'phoney war'[‡] ended in April 1940 and the Blitz began, but my mother was still not well enough to move from our home in Sussex to Devon. On 10 July 1940, the

* HMS *Royal Oak* sunk in Scapa Flow, 14 October 1939, with the loss of 834 men and boys.
† Puerperal fever is a bacterial infection of the female reproductive tract following childbirth.
‡ The phoney war is the name given to the period of time from September 1939 to April 1940 when, after a blitzkrieg attack on Poland in September 1939, nothing much seemed to happen.

Battle of Britain commenced, and my father's regiment was put on standby.

By the end of August but before the Battle of Britain ended on 31st October, my mother was given twenty-four hours by the War Office, via my father, to move herself, her two children and Nanny to the comparative safety of North Devon. I say comparative, because whilst the North Devon coast was not itself a direct target of enemy forces, bombs were dropping in what appeared to be a hit and miss manner all around us. This was because both the Germans and the British would release bombs to lighten the weight in their aircraft, thus effecting a speedier return to base.

My mother's sister, Peggy Nightingale, lived at Lynton with her doctor husband and their two children. They kindly gave us sanctuary for two months while my mother sorted out more permanent accommodation. Goodness knows how two families managed to squeeze into the Nightingales' house. The nannies quarrelled, the children squabbled, and the parents argued. Both families, used to the luxury of space, found the constrictions stressful. The wailing of the air raid sirens, which went off frequently, added to the general feeling of tension.

Up on the Moor

In October 1940 we moved to new lodgings with the Churchill-Longman family, who lived on the outskirts of a small village called Littleham. They managed a working farm and, joy of joys, they had ponies.

The youngest daughter, Vi, nobly taught me to ride on a donkey called Donkey Donk. Later, when we had our own house in the village, she escorted me out hunting on her old pony Pippin. We were fortunate that hunting was permitted throughout the War, largely supported by farmers, many of whom kept the hounds themselves.

The unofficial line put out by the War Office was that the soldiers should enjoy some sort of leisure activity when they came home on leave. Hunting was therefore given the important status of contributing to the 'War effort', which made us all feel very virtuous as we galloped about the countryside.

Despite this, as early as 1949, the first political attempts to ban hunting were brought to Parliament in two Private Members' Bills by a man called Seymour Cocks. Fortunately, for all those in favour of hunting, he 'cocked' up this effort and the sport continued.

Rural North Devon in the 1940s was comparatively primitive. In the first place it was far removed from the rest of the country, with some parts of the large county being very remote indeed. It was not uncommon, sixty years ago or more, to find members of the same family still sleeping in one bed – brothers, sisters, parents – and few people bothered to get married. Not surprisingly, there was a fair amount of eccentricity amongst the villagers, generated by years of inbreeding.

Potty Arthur and Poor Fred were the 'eccentrics' in our village. Although they were harmless, we were nervous of their insane chatter and wild laughter, which made no sense to us. When we children had to pass through the village, we would avoid them by ducking behind a hedge until they had gone by.

Sanitation was also very primitive. Littleham consisted of a collection of cottages bordering a long, winding lane, which meandered through a farming community. Traditionally, this centred around the post office and shop where all news and gossip passed. There was a village pump where people fetched their domestic water. Unfortunately, whilst this was located on the main lane for convenience, it was also lower than the drainage from various cottages and

a chicken farm. Eventually, the inevitable happened and several severe cases of poliomyelitis were reported (the Salk vaccination was not used until 1954). The pump was closed and mains water was brought in.

It was not until Littleham was 'modernised' in the 1950s – in the form of electricity, mains water and drainage – that the old system of doing things was ever questioned. The modernisation works were a major undertaking, for the village was a good three miles from the nearest small town and the rural community was spread out with great distances between each smallholding.

Exeter, a medieval cathedral city – and the capital of the county – lay some fifty miles from Littleham. Until the 1950s, however, most of the village's inhabitants had never been to the local town of Bideford, let alone Exeter. There was no public transport to the outlying villages and very few people had cars. Those who did own a motor were often unable to use it as petrol was extremely limited during the War. Enterprising locals had a pony and trap, and as late as the 1990s it was still possible to see metal rings outside the Pannier market in Bideford where people could tie up their horses.

Less far away lay the North Devon coast with its views, on a good day, of South Wales and Lundy Island. Barnstaple, a larger town than Bideford, was some twelve miles from Littleham. At the time of which I write it was a rural back-water, but during the 17th and 18th centuries it had been a place of some distinction, for the dramatist John Gay, who

wrote *The Beggar's Opera*, was born there in 1685. More notorious was Thomas Benson, the MP for Barnstaple, who used Lundy Island as a base for his successful smuggling business in the 1750s.

From the 14th century until the end of the 17th century, Barnstaple was a well-known centre for excellent gold and silversmiths. John Quick's famous workshop operated there from the end of the 16th century until around 1630 and Robert Mathew, whose silver bore his famous fruit device, operated at a slightly earlier date. 'Barum' was the Barnstaple silver mark, although town marks were discontinued after 1896.

In North Devon it was still possible, even in the late 1940s, to be part of a life which had remained virtually unchanged for most of the century, despite two World Wars. At that time Devonians were still largely ruled by superstition – a strange mixture of paganism and religion – and they had their own folklore. Not, perhaps, to quite the extent of the Cornish people, but the borders between Devon and Cornwall became blurred at Dartmoor, on the edge of which lay my school, Sydenham House.

Black and white magic was still quite widely practised in this area and folk tales, told in the broadest of Devonian accents – a language almost of its own – were salutary and often alarming. Mostly, they were stories about travellers and, more worryingly to us children, horses who, lured by will-o'-the-wisp lights, disappeared as they journeyed over the moors, never to be seen again.

The question: 'Be 'um going up on t'moor, then?' was nearly always accompanied by a sharp intake of breath and a rueful shaking of the head, calculated to put the fear of God into the most seasoned traveller.

The Magic Gang

Whilst we children enjoyed the freedom of the country-side in Devon, my father was having a less agreeable time in the Army. In 1942 he was sent to Egypt, embarking on the SS *Orontes* at Liverpool on 1 June. Because of the blocks* in the Mediterranean, the ship was obliged to make the long journey round the Cape of Good Hope, arriving at Suez on 21 July.

At about this time Britain produced its most daring and secret weapon, a team of illusionists known as The Magic Gang. Headed by Jasper Maskelyne (1902–1973), the Master of Make-Believe, the gang was busy 'hiding' part of the Suez Canal through a complicated system of revolving

* Great Britain considered naval blocks a legitimate method of warfare and had used the system to very good effect during the First World War. In this instance, the Navy used to dictate the movements of commercial shipping routes, so that shipping had to go the long way around to Suez, via the Cape of Good Hope.

mirrors and searchlights designed to confuse the Germans from the air by creating a whirlpool of light in the sky nine miles wide. I am not sure whether my father realised, as he arrived at Suez, that he was caught up in a huge conjuring trick and that the submarines he must have seen on his way into the Suez Canal were largely fake.

Perhaps The Magic Gang's greatest trick was to create an entire 'army' in the Western Desert with more than 2,000 dummy tanks and a half-built pipeline, which could be seen from the air (but which did not exist). Known as 'Operation Bertram', the plan was designed to make the Germans believe that the Allies were going to attack from the south rather than the north. Because of the half-built pipeline, the Germans were also duped into thinking that the attack could not possibly take place before November of that year (1942).

The German military officials relaxed. Erwin Rommel went home on leave and the Allied attack started on 23 October, catching the enemy off-guard. The Magic Gang's successful illusion undoubtedly contributed to the success of the Battle of El Alamein.

Both the 4th and 5th Battalions of the Queen's Own Royal West Kent Regiment, supported by the 2nd Battalion of the Royal East Kent Regiment (the Buffs), took part in the notorious Battle of Alam el Halfa, which was fought between 30 August and 5 September 1942.

History has chosen to record this battle as a great victory for the British, but for the survivors it was a ghastly

nightmare from which my father took a long time to recover. Two hundred and fifty men of the 4th Battalion were killed, wounded or recorded as missing, and of the 5th Battalion only eight officers (35 were sent) and 225 men remained.

My father was second-in-command to Major E. G. Young of B Company, who was an early victim of the battle. It seemed to the survivors, and indeed to many observers back in England, that the 132nd Brigade had been ruthlessly used in a suicidal attempt to cut off Rommel's retreat and expected advance on Cairo. The Army, to be fair, did its best to compensate and withdrew what remained of the two battalions to the coast to recover, receive reinforcements and re-equip.

In the New Year of 1943, the Army then sent the 4th and 5th Battalions to join the British force in Iraq (known as Paiforce) in order to fortify the small British garrison there, which had been set up to guard the oilfields and pipelines.

The journey to Baghdad was made by road through the Sinai Desert, Palestine and Syria. The 4th Battalion took ten days to travel the 1,000 miles but the 5th Battalion had further to go to their camp and were delayed by torrential rain, so they did not arrive until 20 January. Iraq was a relatively quiet backwater at that time.

In May 1943 it was decided that, as German attention was largely focused elsewhere, it was safe to leave the guarding of the oilfields in the hands of the greatly reduced Paiforce and send the 5th Battalion to Syria, by road, where it trained intensively for four months. No doubt it did train

intensively, but there was obviously still time for leisure since there is a small snapshot of my father, dated 7 July 1943, on the back of which is written, 'In our garden at Rushdie Pasha, Ruenleh.'

The picture shows him looking happy and relaxed and it is worth recording here that throughout the rest of his life gardening gave him the therapy he so badly needed. Unfortunately, enjoying the garden at Rushdie Pasha was to be a short-lived pleasure, for on 20 September 1943 the 5th Battalion embarked at Alexandria, bound for Italy, just four days after the British 8th Army and the US 5th Army had united their fronts, south-east of Salerno, on 16 September.

For the Allies, the Italian campaign was to feature some of the fiercest fighting of the entire War.

My father is second from the right.

The Great Survivor

My family has always thought that my father took part in the Battle of Cassino (also known as the Battle for Rome) but he did not. There were four attempts to capture the monastery (founded by St Benedict in 524), which was perched on a hill above the town at Cassino. The battles took place between 17 January and 19 May 1944, but while my father's battalion was sent to areas surrounding Cassino, and on 4 May went behind the frontline to help prepare for the fourth battle, it did not enter any of the battles for the monastery itself.

On 28 December 1943 my father (by now a Captain) was wounded in the head at Villa Grande, a suburb of the small seaside town of Ortona on the east coast of Italy, where eleven men of the 5th Battalion died and fifty were wounded.

The 5th Battalion had joined the Moro River campaign, which was part of the 8th Army's drive across the Winter

Line. The river Moro was the centrepiece of the Gustave Defensive Line, a heavily defended strip that started south of Gaeta on the west coast of Italy and ran across the country to just north of Ortona on the east coast, thus preventing the Allies from moving north to Rome.

Mud and heavy rain prevented the majority of Field Marshal Montgomery's forces from breaking through the line and it was the 1st Canadian Infantry Division, ably backed up by the Seaforth Highlanders and the Lovat Scouts, who actually did so, at Ortona on the Adriatic coast, very close to where my father was fighting at Villa Grande.

The Battle of Ortona (Villa Grande), which was small but extremely fierce, took place between 20 and 28 December 1943. It was fought pretty much hand-to-hand between German paratroopers and the Allies. My father (by now a Major) did not have long to recover from the wound he had sustained at Villa Grande because on 20 May 1944 he took part in the Battle of Piedimonte. This time he was wounded in the leg.

I remember him coming home on leave walking with a limp and a stick. The stick and the limp remained for a long time after the War. His head injury also gave him trouble for some time. As a temporary measure the leg wound had been stuffed with bits of khaki uniform to plug the hole. For ages afterwards, small pieces of khaki were to work their way out of the wound. On 11 January 1945, my father was mentioned in a Despatch for distinguished service.

Years later, in 1971, my father made a speech in which he

described himself as 'a man who seemed to attract events'; it is interesting that he saw himself in this way as he was someone who never sought adventure. Rather, he was a gentle and sensitive person who, if given a choice, would steer away from trouble. He was clearly puzzled as to why trouble followed him when he was at such pains to avoid it.

He numbered amongst the events he had survived four emergency aircraft landings, two earthquakes, a bomb scare on an aeroplane to South America, and being hounded by a posse of headhunters, bent on removing his scalp.

I remember him telling me about the earthquakes. How, in the first instance, the ground had opened up in front of the aeroplane he was in as it was taxiing to take off, and how frightened the passengers were that the plane would fall into a crater. The other earthquake struck when he was in a hotel. All the furniture fell about the bedroom and the ceiling came down. I believe that he was lucky to get out alive.

I am not sure whether he was involved in the largest earthquake in the world, which occurred in Chile on 22 May 1960 and measured 9.5 on the Richter scale, but it is possible. He was certainly in South America then, and would have had time to arrange his getaway – just.

One of the reasons that there were comparatively few casualties in that Chilean earthquake was because of an efficient early warning system, which ensured that many people escaped. An earthquake in Peru on 31 May 1970, on the other hand, with a magnitude of 7.9 on the Richter scale, killed 66,000 people.

In that speech of 1971 my father did not include his narrow escapes during the War in his list of 'events'. My view is that he was a very brave man, if only because he knew great fear and overcame as much of it as was possible until his death on 21 June 1996.

By the KING'S Order the name of
Captain (T/Major) J. McC. Wollaston,
The Queen's Own Royal West Kent Regiment,
was published in the London Gazette on
11 January, 1945,
as mentioned in a Despatch for distinguished service.
I am charged to record
His Majesty's high appreciation.

Secretary of State for War

Children of War

One of the great advantages of being a child during the War was that we learnt very early on that stuff happened – most of it abnormal – and that children just had to deal with it. Fathers were absent; sometimes they never came home. Or, they came home with terrible wounds which created havoc in their lives and the lives of their families. Some suffered from shell shock and it took years to rebuild their confidence.

Mothers were under constant stress and were often short-tempered and brittle. They lived in a state of fear and we children walked on eggshells around them, realising that they had little emotional energy to spare for us. As a result, we learnt to comfort our contemporaries ourselves. We learnt diplomacy and perception – at least I think we did – and how to deal with our feelings as best we could, in silence. Emotionally, we were mature beyond our years, as

we knew that we needed to be mentally strong to survive.

One of the disadvantages of being a child during the War was that education was inadequate. Most of the best teachers had gone to fight or do War work and the teachers that were left were largely elderly with old-fashioned methods and ideas.

In any case, there were not enough teachers to go around so classes were large and badly disciplined. Bullying was rife. For me, who was considered 'thick', the lack of a decent education wasn't viewed as particularly important, except that I would have liked the opportunity to become a lawyer, thus following the profession of so many members of my family. For my sister, Ione, however, who was very bright, it mattered quite a lot.

PoWs

Throughout the War, and for a surprisingly long time afterwards, there were German and Italian Prisoners of War working in supervised gangs on the farms in our area. By the end of November 1947, 47,000 PoWs had been repatriated from Britain at a rate of 15,000 a month; by the summer of 1948, all prisoners were repatriated who wanted to be.

In Devon anti-German feeling was intense. I vividly recall my Devon 'minder' viciously spitting at the PoWs as we passed them on our afternoon walks. 'Filthy pigs,' she screamed. Whilst embarrassed by her behaviour, I also had feelings of great loyalty to both her and my country. 'Filthy pigs,' I chanted, aged about six, and spat at the cow parsley in the hedgerows all the way home.

Given that the feelings I witnessed were obviously not unique, it is surprising that there were relatively few civilian

attacks on German PoWs in Great Britain. Incidents did occur, however: *The Times* reported the murder of one prisoner, kicked to death in Northumberland, as late as 8 November 1947. Sadly, and almost certainly as a result of the feelings I absorbed as a child, I have never been able to view Germany and the German people with as much *entente cordiale* as I would like.

During the late 1940s and early 1950s, rationing in Great Britain slowly came to an end. Clothes rationing finished in March 1949, having started in June 1941, followed by petrol rationing in May 1950 and soap rationing in September. Soap rationing had started in February 1942. Sweet rationing ended in February 1953, the same month as War deserters in Britain were granted amnesty.* Butter was the last to go, in May 1954, ending a fourteen-year period of food rationing.

* On 24 February 1953 an amnesty for War deserters who had fled between 3 September 1939 and 15 August 1945 was announced by Winston Churchill in the House of Commons as part of the Coronation celebrations.

The Terrible Winter
of 1947

My mother bought Hollands in 1946 for £350. Originally two labourers' cottages, with two and a half acres attached, it was on the edge of the village of Littleham. Built in the original Devon style – cob walls, dirt floors, no sanitation, and a thatched roof – it needed the grand sum of £2,000 spent on it to transform it into the charming family home she came to love.

The renovation work was supervised by Mr Cox (senior) whose building company in Bideford was well-regarded. Mr Gratton was the thatcher who replaced, or patched, the roof over several years. He was difficult to get hold of, however, and was usually booked for months in advance. When we did manage to fix a date, he would often ring the day before

he was due to start work to say: 'Darn me, I baint well,' or, more likely, 'Can't do thatchen this weather.'

Not surprisingly it took a year before the work was completed and we were able to move in. During this time, we became PGs (paying guests) in a small, detached annex at Knapp House, a hotel on the edge of Northam, owned and run by Commander Marshall and Mrs Dinah Pratt. The delay in the building work was not helped by the terrible winter of 1947 when sub-zero temperatures and a serious fuel shortage made it one of the coldest on record. Having just moved into Hollands, the freezing conditions meant we promptly had to move out and go back to Knapp House.

On 29 January 1947, the temperature fell to -16 degrees and by the beginning of February the snowfall had reached record levels, cutting off villages all over the country. Even Buckingham Palace was lit by candles due to long periods of power failure. Thank goodness for the Prisoners of War, 500 of whom were recruited to clear the main roads which blizzards had made impassable.

Littleham was completely cut off for a month and I wish we had been as enterprising as the inhabitants of Widecombe-in-the-Moor, on Dartmoor, who, on 12 February, sent a telegram to the Ministry of Food in London saying:

'NO BREAD SINCE 27 JANUARY. STARVING.'

The Warren at Walmer

Gradually, life returned to normal after the War. Ione and I resumed our trips to Walmer in Kent, where my Wollaston grandparents lived in an extraordinary rabbit warren of a house. Originally built in 1842 by my great-great-uncle as a small, square, early Victorian villa, it had been frequently added on to as the family expanded. Thereafter, it remained in a time warp – a relic of the style of decoration fashionable at the end of the 19ᵗʰ century.

By the time we children came along, Walmer had acquired wings and floors on all levels. Bathrooms were scarce and the house was lit by gas – it was not connected to electricity until some time after 1961.[*] Even then, the family had to sneak in the upgrade, my grandfather having died in 1957, and my grandmother having to spend some time in hospital

[*] According to my cousin Hilary McCall in his book *The Children of Ulsterman KC and Alice*, the gas lighting was still in place when he visited in 1961.

after breaking her hip. She would never have authorised such a move herself.

My sister and I slept in the night nursery at the top of the house. Next door to our room was the day nursery, which housed many of the toys that my father, aunts, and uncle had played with when they were children. In the middle of the room was the old nursery table, and in the middle of the table sat a musical box, with which we were never allowed to play unsupervised. It had belonged to my grandfather when he was a boy and must have been more than a hundred years old. We thought that it was the most beautiful instrument we had ever heard and would plague my grandmother to wind it up for us.

Looking back, I realise that my grandmother had that most precious of all qualities – patience. She was generous with the time she devoted to her grandchildren, too. She suffered from very bad legs, and I am now aware of how tiresome it must have been for her to toil to the top of the house every two minutes to satisfy our needs. If she felt irritation, she never showed it.

The gas lighting throughout the house created shadows which often frightened us. My sister and I were terrified of turning off our light before going to sleep and a great deal of energy was spent in trying to persuade the other that it was her turn to get out of bed and pull the gas chain. I usually lost the argument, on the grounds that I was the elder and the light was on the wall closest to where I slept. On the other hand, I sometimes pulled rank. Whoever lost

the argument had just enough time to pull the chain and jump back into bed before the light, spluttering and hissing, went out and plunged us into darkness.

My grandfather Wollaston was a multi-talented man. He had been at Harrow with Winston Churchill, although a term behind him, and contributed the first chapter, 'Churchill at Harrow', to the book *Winston Churchill by his Contemporaries*.* This chapter is well worth a read, since it is full of dry and pithy wit. The anecdotes attributed to Winston that my grandfather records will have been well-researched and accurate, but he has not been able to resist the urge to have some fun at Winston's expense, as well. My grandfather made the point that, without a crystal ball, no one could have distinguished the brilliant Churchill from any other small boy newly arrived at the school, except perhaps the headmaster, Dr Welldon, whose powers of vision must have been exceptional as he admitted Winston to the school on a completely blank Latin entrance exam paper. After two hours of concentration Winston had been unable to answer a single question!

Many years later Winston and he fell out over the abdication of Edward VIII. My grandfather, a great traditionalist, urged the King not to give up the throne – and not to marry Mrs Simpson either. Churchill took a more lenient view.

Surprisingly for such a small man – he was 5ft 4ins in his socks – my grandfather married a woman nudging 5ft

* Edited by Charles Eade and published by The Reprint Society, London, in 1955.

10ins. Unsurprisingly, my grandparents were known as 'the long and the short of it' whenever they appeared in public together. Their ill-matched appearance also extended to their recreational choices. My grandmother was a Dame of the Order of St John of Jerusalem and devoted herself to local good works. She did not 'do' games and sports. My grandfather's great loves were tennis, music, sailing and riding. After leaving Cambridge, he studied music in Dresden for a year before abandoning it in favour of law and The College of Arms.

Quite often he played the organ, which his father, Sir Arthur Wollaston, had installed in the music room at Walmer. Whenever we children were there we were bullied, but sadly never bribed, to pump the organ when he wished to play. About once a month the family was driven to Canterbury Cathedral where my grandfather would sit, long after the Sunday service was finished, listening to the organist playing.

Riding was another of his hobbies. He was a prominent figure in the hunting field up to an advanced age. Because we shared a great love of horses, a grey pony called Jimmy was hired for me to ride on my visits to Walmer. My grandfather, who by that time had given up his own horse, hired a large, reliable hack from the local livery yard. Jimmy, on the other hand, who was very far from reliable, would seize any opportunity to whip round and beat it off back to the same yard.

Grandfather Wollaston was a man of few words. Whether

this was by inclination or because he always had a cigarette drooping from his mouth, which clearly made conversation difficult, I do not know. The nicotine from the permanent cigarettes clamped between his lips had stained his white moustache ginger and since he was almost bald it was many years before I realised that ginger was not his natural hair colour.

Despite the impediment of speech due to the cigarette he would order me, between virtually closed lips, to follow the tail of his horse and to shout if I was in trouble. There was no question of us riding together. Since I was often in trouble, I shouted frequently, but I do not remember him ever turning around to help me.

He would, however, eventually become aware that Jimmy and I were no longer behind him, after which he would retrace his steps, very slowly, to find that Jimmy and I had parted company some miles back. Usually, I had been unable to retain the reins of the beastly pony, which meant a long walk back, in silence, to the stables.

Both my grandparents were influential during my childhood, although the War did its best to ensure that we did not meet much until I was eight or nine years old. In those days, the problems of distance were far greater than they are today. We were in Devon and my grandparents remained at Walmer during the early years of the War, until family pressure compelled them to move to my aunt's house in Hertfordshire, which was thought to be safer than Kent.

They were still at Walmer in 1940, though. We know

as, in late May of that year, with the British Expeditionary Force surrounded at Dunkirk and seemingly doomed, the call went out for all seaworthy vessels to get the soldiers off the beaches. My grandfather sent his small boat to join the fleet of other little craft helping the evacuation. My grandfather had longed to go himself, but my grandmother forbade him on the grounds of age. He was sixty-six.

Between 27 May and 4 June, 299 British warships and 420 other vessels evacuated 335,490 soldiers. Codenamed 'Operation Dynamo', this amazing exercise, undertaken by any boat that was remotely seaworthy, and manned by determined countrymen under constant attack, goes a long way to illustrate the spirit of Rule Britannia; I can well understand why my grandfather would have wanted to do his bit.

He was particularly disappointed because 'old' Joe Mercer, his unofficial boatman, who would have taken up the challenge to go to Dunkirk with him, was currently coxswain of the Walmer lifeboat. Named the *Charlie Dibdin*, it was one of nineteen lifeboats that took part in the evacuation.

When he wasn't crewing the lifeboat or keeping an eye on my grandfather and his single-handed sailing exploits, Joe Mercer* was a luggerman (a lugger is a class of boat widely used for fishing). The work of the Deal 'luggers', as they were known, was so dangerous that at one time Lloyd's of London refused to underwrite the risk and consequently

* Joe Mercer was one of six Walmer lifeboat men who acted as escorts to the coffin at my grandfather's funeral in March 1957.

Joe Mercer, Christmas 1953.

all the boat owners and, more importantly, the men who manned them, were uninsured.

My grandfather's battle-worn boat was used long after the War had ended. With foresail, mizzen and mainsail to manage, Grandpa would sail her single-handed if there was nobody to crew for him, and, very often, there was not. 'A nice afternoon for a sail,' he would announce at lunch and suddenly everyone would remember that they had plans for the rest of the day.

Both my father and my uncle dreaded having to take their children out in Grandpa's boat, for she was heavy and unwieldy. Often, there was no outboard motor to use in the event of a problem. 'Going about' was a hazardous operation (which, I noticed, never seemed to trouble the children in *Swallows and Amazons*) and sailing her in the annual Deal and Downs Regatta* meant we usually came last.

* The Downs is the piece of water which lies between Deal and the treacherous Goodwin Sands, on which the remains of more than 2,000 boats lie.

My Parents' Divorce

It was at Walmer, during the summer of 1946, that I first became aware of the extent of my father's trauma, presumably because of the battle action he had seen over the previous three years (1942–1945).

One of my grandfather's two horses had survived the War and my grandfather was keen to see my progress (or lack of it, as it turned out) at riding. The horse, with me on its back, was put into the paddock where my grandfather leant against the iron railings, the better to watch this eight-year-old 'child wonder' perform various equestrian feats. And feats he certainly witnessed…

The horse gave two short bucks and, failing to dislodge me, set off at a rapid pace around the paddock while I clung to his mane. It was immediately obvious to my grandfather that both the horse and I were out of control, so my father

was urgently dispatched into the paddock to rescue me and, more importantly, the horse.

Unfortunately, my father was unable to take any action. Although he tried to move towards me, he remained rooted to the spot. The louder my grandfather shouted instructions at him the worse it became; he was literally paralysed by fear. Meanwhile, the horse, which was far too big for me, continued to race around the paddock in a bid to dislodge his mount.

Although I was very frightened, I was also determined to stay seated for as long as I was able and continued to cling on like a monkey. Eventually the horse got bored, or tired, and made his way back to the railings and my grandfather.

When my father caught up with us his hands were shaking so badly, he could barely hold the bridle. He was unable to speak, in his defence or otherwise, when my grandfather berated him for what seemed like an act of gross incompetence.

Reality kicked in and it dawned on me then that this was not a man who was going to jump onto a white charger and rescue my sister and me from our Devon home, where my mother's wild mood swings were beginning to give us both serious cause for concern. He had enough demons of his own and I realised, a good two years before my parents divorced, that there was no room in his life for needy people like his wife and two young children.

All my father wanted was a quiet life. He came from a

generation that could not admit to emotional trauma, even as a result of the War. The stiff upper lip, so carefully cultivated at British public schools, had not yet crumbled as it was to do in later generations. At this point in the 20th century, it was merely allowed the occasional quiver.

As I had correctly surmised, our parents' marriage was heading towards divorce, although I do not think I realised quite how ghastly the two years leading up to it would be. My mother lurched between apoplectic anger, usually sparked off by some small misdemeanour by her children, and full-scale rages, bordering on madness, whenever she had any communication with my father. My parents were no longer living together at this point. My father's work at ICI meant that he needed to be in London and my mother refused to join him on the grounds of ill-health. And there she had a point.

When the divorce finally came through in 1948 it was almost a relief, although Ione and I were both painfully thin by this time. This could not, of course, be attributed to stress since children did not suffer from stress in those days. It had to be an attack of worms for which we were duly treated with bitter-tasting purple pills. God knows what was in them, but we went on being thin, so we went on taking them.

In desperation, Granny got in jars of malt extract, which she fed to us by the spoonful. I loved it but any weight we put on in the two weeks we spent at Walmer each year was rapidly lost on our return to Devon. At one time our

diet seemed to consist solely of slices of white bread and dripping – my mother's answer to weight loss – and purple pills – which had the reverse effect.

Uncle Andy

My mother and father divorced in 1948 and almost immediately, on 20 July of that year, my father married Dora Grace Bastable. Everybody, including us children, was encouraged to call her Bunny.

Bunny had been married twice before and was six-and-a-half years older than my father, which spoke volumes about his emotional needs. I think he saw her as his salvation; I do not believe that he ever learnt that emotional strength can be found only in oneself.

Bunny had one daughter, Prudence, but whether she was from Bunny's Bastable or her Brewton marriage I am not sure. Bunny had been, once upon a time, a Miss Walker, the daughter of William Walker of Southsea.

A year later, on 21 June 1949, my mother married Andy Garland. A Scottish bachelor, who was twenty years older than her, he became Uncle Andy to us children. All in all,

their marriage was successful and lasted until his death in 1972.

Despite feelings of loyalty towards my father, Ione and I rather liked this new addition to our family, with his funny expressions picked up from around the world. 'Cupboarda,' he would say in a conspiratorial whisper. 'What exactly does that mean?' I would ask. 'Prenez garde,' he would reply, lowering his voice to a mutter. 'Oh, I see,' I said knowingly. I had not had a French governess for nothing.

'Bonski onski' was another of his favourites, whatever that meant, and 'Pukka Sahib'. This last expression, presumably picked up from his many years in India, was accompanied by a tap on the side of his nose indicating, I suppose, that whomever he was talking about was either socially acceptable, or not.

'Do you think you could get the Ryder Cup captain to sign my autograph book?' I asked Uncle Andy one year, when the team was playing golf at nearby Westward Ho! And he did. Not only the captain but the signatures of all the other players, too. 'What a hero!' I thought. I have remembered that kindness all my life.

Andy Garland was born at Carnoustie on 19 April 1893. He had been a lawn tennis champion in India between 1927 and 1936, whilst also finding time to make his fortune in jute. On his early retirement in 1936 he had intended to base himself in the South of France and play tennis and golf for the rest of his active life. Fate had a different idea.

In the first place there was the Second World War, which

found him stranded in North Devon. He was staying with the Grahams, friends of his from India, who had rented a house in Westward Ho! for three months in order to play the Devonshire golf courses.

A victim of gas inhalation during the First World War, Andy was pronounced medically unfit to fight in the Second World War, joining the Home Guard under the leadership of Brigadier Reid instead.

After the War there was marriage to my mother. An unexpected decision for, at fifty-five years old, getting married had not been foreseen. Then there were the two children he suddenly acquired. This must have been a further shock, for children had not been high on his list of 'must-haves'. The final blow came when he realised that, with three extra mouths to feed, the money he had set aside for his retirement was not going to be enough. And so he took the job as Secretary at the Royal North Devon Golf Club.

Although golf had never been his number one sport, Andy remained a scratch player (a golfer who can play to a course handicap of zero on any rated golf course) until he was quite old. He had learned his game as a young man, at the Royal Calcutta Club in India – the oldest in the world outside of the British Isles.

Although he loved golf, Andy was not a patient tutor of the game. Cajoled by my mother to teach his stepdaughters how to play, there were surely moments as he stood with us on Westward Ho!'s windy and inhospitable links when visions

of his imagined retirement in the South of France must have danced invitingly before his eyes. He would almost certainly have wondered why his plans had gone awry.

The RNDGC

The Royal North Devon Golf Club (RNDGC) was instituted in April 1864 and is the oldest links in England. Once a championship course, it has a distinguished history. Situated in Northam, it was the boyhood home of J. H. Taylor, the legendary Open Golf Champion (1894, 1895, 1900, 1909, and 1913), who was born in 1871.

It was also the boyhood home of Horace C. Hutchinson, who was still at Radley when he won the Scratch medal of the Club Autumn Meeting in 1875. From an historical point of view, it is interesting that the first English amateur to win the Amateur Championship (Hutchinson) and the first English professional to win the Open Championship (Taylor) both came from North Devon.

To us children, unmoved by fame, the links at Westward Ho! represented nothing more than a bleak expanse of land,

6,540 yards long, over which the wind blew at gale force with depressing frequency.

Until the First World War, there had been a train known as Puffing Billy, which ran alongside Pebble Ridge, from Westward Ho! to Bideford, via Appledore and Northam Burrows. 'Puffin' Billy might have been a more appropriate name for it because you can see Lundy Island, home to numerous puffins, from Westward Ho! Sadly, since the little locomotive was much loved, the boat carrying it was torpedoed, ironically off Lundy, whilst transporting it to France, where it had been ordered to take up duties halfway through the War.

The heyday for golfers at Westward Ho! was undoubtedly between 1875 and the First World War. But the course remained a formidable challenge for many of the best players in the world during the 1920s and 1930s (HRH the Prince of Wales became Club President in 1932). Unfortunately, when Andy joined the Club as Secretary, it was in a poor state due to the grassy coastal plain of Northam Burrows having been commandeered by Combined Operations as part of their training ground in the Second World War.

J. H. Taylor wrote in 1944:

Among other disadvantages that Westward Ho! suffers from during these troublesome times is the fact that the course has been taken over as a practice bombing site by the RAF, which utilises it as much as three or four times a week. The whole of the course, apart from the 1st, 2nd, 12th, 15th, 17th and

18th holes, is enclosed with a barbed wire fence, gates being erected at suitable places to let the players in and out. I never thought I should live to see the old place put to such, may I say, ignoble use.

While the men's course was reduced to six holes during the War, the ladies' course disappeared altogether. It was there that the Bailey Bridge[*] was tested across the famous Pebble Ridge. More than 40ft high, it was not only a feature of the landscape but of our childhood as well.

After the Second World War the Golf Club's funds were desperately low, and labour was hard to find. The few groundsmen who were available despaired of ever entirely ridding the course of barbed wire. Ponies and cattle ran wild, cantering over the greens and kicking up the turf, and the links, which had always had pot-wallopers' rights, acquired an uneven surface more in keeping with a sponge than the velvety smoothness of a championship course.

Pat Ward-Thomas summed up the situation well when he wrote in *The Guardian* in 1955: 'For reasons beyond the Club's power to overcome, the links are no longer fashionable for championships. The ancient grazing rights, which permit sheep and cattle to wander at will, are inclined to produce golfers who prefer their pastures to be undisturbed and do sometimes jeopardise maintenance.'

* The Bailey Bridge, a prefabricated truss bridge, was erected over the Pebble Ridge during the Second World War as part of the amphibian landing training for D-Day. It remained in position until the lease to the Ministry of Defence ended in April 1961.

It says a lot for my stepfather's financial acuity that, during his eleven years as Secretary, he overcame many of these difficulties (but never his battle with the roaming animals) and restored the Club's finances to a going, if not wildly successful, concern once more.

John Nott, later Margaret Thatcher's Minister of Defence, was amongst several young people who played golf at Westward Ho! after the Second World War. I do not remember him being very good, although he will probably deny this. His father was a friend of my stepfather and John and his sisters were frequent visitors during the school holidays.

Although John is only slightly older than I am, I remember my mother committing the ultimate humiliation by asking him to keep an eye on my sister and me when we all travelled to London on the train. Both Ione and I were in our late teens at the time and no longer small children.

Before 1 January 1948, when the rail companies were nationalised to form British Rail, we used to travel to London to visit relatives by steam train. The Great Western Railway express from Bideford reached London in five-and-a-half hours.

Usually, we caught the 10 o'clock train. Before the locomotive rolled away, my mother would run up and down Bideford platform entreating anybody bound for London to keep an eye on us. No parent would dare to do that now but in those days her trust in the kindness of strangers was never abused.

I have no doubt that for those travelling first-class, with lunch in the restaurant car to enjoy, the journey proved a pleasant diversion. For us children, however, sitting in a third-class compartment with just a packet of sandwiches to eat, it was an immensely long and boring pastime.

The Long Gallery

After the divorce from my mother, my father seemed reluctant to pay any more than the minimum amount to keep his children from starvation. He considered state education a waste of time and private education for a girl who was considered 'thick' a waste of money. I was fortunate, therefore, to have Andy come to my rescue when I wanted to go to boarding school.

I left West Bank, my day school in Bideford, at the end of the Christmas term, 1950. I was thirteen and had been there for four-and-a-half years. During that time, I had shown little talent for any subject except history and was a very unhappy girl.

After much searching (it seems that I was unsuitable for many schools, given my academic 'shortcomings'), my mother and Andy finally chose Sydenham House, a boarding school at Lewdown in Devon. It was probably one of

the best decisions they could have made for me at that time.

I started at Sydenham House in January 1951. Mrs Stickland, the headmistress, and her deputy, Miss Heath, were both charmingly old-fashioned and ran the school on traditional lines. This meant that whilst the educational curriculum was diligently adhered to, the range of lessons offered was unlikely to prepare pupils for much more than a genteel life. I suppose that this did not worry anybody at the time; it is only with hindsight that we realise it may have been a mistake.

Dressed up in our best frocks, whilst doing some gentle sewing and listening to a story being read to us in the Long Gallery, seemed like light years away from reality even then, but it was an invaluable period, helping me to recover from the trauma of the previous years and acquire a much-needed sense of security.[*]

Those evenings in the Long Gallery were where all the school assembled, and glancing across at the senior girls I could not have imagined in my wildest dreams that years later my daughter, Emily, would marry Belle Atkinson's son, Adrian, and that Belle and I would become not only good friends but grandmothers to our beloved grandchildren. Even stranger than that, and at the corresponding time, Belle's future husband, Chris Lee,[†] and my future husband, David Wingfield, were also at school together.

[*] It is perhaps worth mentioning here that between 1940 (our move to Devon) and 1949 (my mother's remarriage) we had moved nine times, as PGs, in as many years and had had no permanent home.

[†] Brigadier Christopher Lee CBE. Born 1 January 1932.

This made a very strong bond which held the four of us together through good and not so good occasions in the future, but at the time of which I write, aged thirteen, I barely knew Belle Atkinson and her elder sister, Jane, who were both senior to me in the school and, it seemed to me then, seriously grown-up.

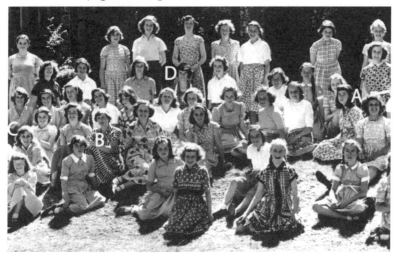

A Mary Ann Wollaston (Wingfield); B Belle Atkinson;
C Elisabeth Pedder; D Caroline Combe

I was very fortunate to make some really great friends at that time and I have kept in touch with many of them over the years, including Elisabeth Pedder, as she was then, who married Tony Humphryes when she was nineteen and is godmother to my son, Charles. Their daughter, Victoria, is a good friend of my daughter Emily, and so the cycle of life goes on!

Sydenham House was a beautiful Elizabethan manor belonging to the Despencer-Robertson family. During the

Second World War it became home to the senior school of the famous Glendower School, which still has its headquarters in London's smart South Kensington.

The children are identified by a purple tunic, blazer and beret, which was also the uniform of the senior school when I started at Sydenham House in 1951. At least the beret and blazer were, and although some of the younger girls still wore a tunic this was phased out as girls went up the school in seniority.

As I have mentioned earlier, lack of staff was a very real concern during the time that I was at school. Our much-loved Miss Heath, who taught us history and a great deal more besides, also doubled up as the games mistress and coached us in tennis and hockey. This was clearly ridiculous since she was very elderly, could not run and served underarm.

There was always plenty of opportunity for a group of us to lean up against the goal posts and chat whilst 'Heather' was occupied at the other end of the hockey pitch. At the speed she travelled, we knew it would be some time before she arrived down our end to disturb us.

Even though the War was over, we still had to 'Make Do and Mend'. It was just the way it was. Rationing continued to be enforced, and in 1951 butter rationing was still very much a part of our lives. Children were allowed 2oz of butter for the week, which was handed out in coloured plastic tubs with screw-top lids, on which was printed our name.

It was interesting to see how each schoolchild dealt with

their ration. Some immediately divided the butter into seven small squares, one for each day of the week. Others, like me, gobbled it up in two or three days and then fell back on the dish of margarine, which was always at each end of the table.

During the summer, however, the girls who carefully stored their butter came a cropper as, towards the end of the week, most of their carefully divided rations had gone rancid in the heat. The butter must have tasted as ghastly as it smelt.

Sweets were still rationed, and on Saturday afternoons we walked two miles to the village shop to buy our quota. Handing over the coupons in our ration books we feasted on sherbet licks, violet creams (which should have been renamed 'violent' creams) or whatever other ghastly confection there was on offer.

Since Sydenham House was close to the edge of Dartmoor there was general alarm, from time to time, when one of the inmates from the high-security prison there escaped. We were on the list of suspected boltholes since, on at least two occasions, the missing convict was found in our boiler room, curled up for warmth on a pile of coats.

Our maths master, who frequently had to double up as janitor, became rather blasé about this, merely murmuring as he passed Mrs Stickland, 'Man in the boiler room again.' This, of course, had her racing for the telephone before any of the girls could get wind of the unwelcome guest. She knew her students well. Far from turning the convict in,

the girls, had they known of his existence, would be secretly bringing him food and helping him plan his getaway.

My happy existence at Sydenham House ended abruptly in January 1953 when my mother removed me from the school on the grounds that my stepfather could no longer afford the fees. She wanted to send me to a crammer instead, so that I could take my GCEs a year earlier than was scheduled at my school.

In vain did Mrs Stickland plead that not only was I too immature to cope with the trauma of taking the exams so early, but that I also needed to be with my contemporaries rather than the elderly couple my mother had organised for me to stay with. In this, of course, she was correct. I was a withdrawn child at best, and at worst downright reclusive. I needed to learn how to integrate with my peers and the fact that the opportunity for this was limited has proved a definite drawback in later life.

My mother refused to listen and so, at the age of fifteen, I was packed off to Budleigh Salterton in East Devon to live with Dr and Mrs Jalland for six months. I will never know what sort of 'improved' person I might have become had I spent that extra year at school, but I do know that I loved my time with the Jallands, for it was with them that I discovered literature.

Unlike my own home, where there were very few books – and those that were available, such as the Jeffrey Farnol and 'Romany' books, I had already read (illicitly) several times over – the Jallands had Trollope, Thackeray, Dickens

and many other classics, which I devoured with a seemingly insatiable hunger.

Hour after hour, when I was supposed to be doing my homework or writing letters home, I would sit in my bedroom reading every book I could lay my hands on. It was liberating. My mother had always viewed time spent curled up with a good book as an indulgence which was not to be tolerated.

It was whilst I was at the Jallands' that sweets and biscuit rationing was lifted (February 1953). One of the downsides to the enforced food rationing in Britain was that I was fifteen before I discovered these luxuries in any quantity. To celebrate, I went out and bought packets of biscuits and pounds of chocolate. Three weeks later I had not only gained about a stone in weight but was covered in boils. A boil on my leg turned into an abscess so large that the hole it left when it burst can still be seen on my leg.

Bea Jalland was a brilliant tutor, which was fortunate since I hardly ever looked at my homework. Well, how could I? I was too busy reading and eating sweets. I was not, on the face of it, destined to pass many exams. On the other hand, I loved the three subjects Bea taught so, against all the odds, I did pass history, English language and English literature, although not with the flying colours she would have liked – or deserved.

I was rather disappointed not to pass divinity, which was the only subject taught to me by Dr Jalland, who was a specialist in the scriptures. I was fascinated by the history of

the Old Testament and did my best to learn all I could from this most knowledgeable, if somewhat eccentric, man who wore purple socks every day. Unfortunately, I think that the exam questions must have focused on the New Testament with which I was not as comfortable. At any rate, I failed.

Bea Jalland had a great sense of humour and on the rare occasions that we went out together – time did not permit much socialising – we hugely enjoyed each other's company. It was through her that I first met the Bishop of Exeter and the Mortimer family.

Both Bea and Mrs Mortimer served as governors of the Maynard School for Girls in Exeter. After their governors' meeting (which I did not attend), we would meet up to have tea or a drink with the Mortimers at their apartment in the Palace before trundling back to Budleigh Salterton.

Twice a week I was supposed to play golf at the course at Budleigh Salterton, which Andy had arranged with the Secretary there. Since I did not play very well, and did not want to play on my own, Andy planned for the seventeen-year-old son of the professional at the Club to accompany me.

He was a very good player. He was also very willing to play with me. In fact, a great deal too willing, I noticed, as we battled our way around the course. We made another date to play golf and then another... Luckily, I was able to make the excuse of pressure of work, followed by my leaving Budleigh Salterton for good, to terminate a friendship which, I felt, might be getting out of hand.

At least I thought I had terminated the friendship, so I was somewhat taken aback a year later when my admirer turned up in Oxford, where I was working as an assistant matron at Christ Church Choir School, with a large bunch of flowers. My delightful and long-suffering boss Mrs Muller and I entertained him for tea in her little sitting room and we had a fun time.

We were never remotely lovers (far too frightened for that) but we had formed a friendship in those early teenage days, which was even more special because there was no parental intervention on either side. I never met his parents and he never met mine.

Religion

North Devon in the 1950s was a predominantly Low Church community – Chapel and Methodist. It was unusual, therefore, to have a High Church priest in charge of a small, rural parish whose flock was uneducated in the traditions of High Mass and did not, in any case, understand Latin.

Thackeray, writing of his tour in Ireland, in 1842, referred to the confessional as 'the great terror-striker', but he could easily have had Littleham church, under the auspices of Father Clark, in mind when he wrote it.

Father Clark celebrated mass every Sunday, but the villagers stayed away. No confessionals for them. He made little effort to integrate within the community. Instead, he and his wife sealed themselves away in the large Georgian rectory and few people came to their door. The community was suspicious of a religion that they did not understand, and

they were afraid of the surly priest in his long black clothes.

My mother, who had been brought up in an Anglo-Catholic family, was a High Church worshipper herself before she became a Roman Catholic. We children, therefore, were obliged to attend church on a regular basis.

The church organ was rarely used. Instead, a harmonium was played by Miss Bucket, a saintly soul who was persuaded to undertake the three-mile walk there and back each Sunday from Bideford. Miss Bucket was not a good harmonium player and was rendered useless by the furious looks directed at her by Father Clark whenever she struck a wrong note. Fortunately, the congregation, which never exceeded more than five worshippers, viewed her efforts with a good deal more tolerance than he did.

In due course the subject of my confirmation came up. Who would prepare me? My heart sank for I knew that Father Clark was the obvious candidate. I prayed that he would find an excuse to avoid taking up the challenge, but it was not to be. In the event, Father Clark turned out to be a conscientious and learned tutor of divinity and, to my surprise, I found that I enjoyed my lessons just as I had enjoyed Dr Jalland's tuition.

On the other hand, it was fortunate for both of us that my love of history and my enquiring mind largely overcame my fear of him, for I did not find him a charitable person. After my lesson finished, he would show me straight to the back door in silence. No attempt at conversation was made. Nor was there ever the offer of a cup of tea or any other

form of hospitality shown by either him, or his wife, to any of my family. He was not someone to go to if you were in trouble and needed help.

Father Clark came back on the scene for my first communion which took place in Bideford church and was presided over by the Bishop of Exeter. He reappeared again before my wedding in 1961 and on both occasions his manner was the same. The formalities over, there was nothing more he had to say, apparently. A truly strange man.

Crossing the Channel

In September 1949 I went to stay with the Foch family in France to improve my language skills. The Fochs' eldest son, Remi, had stayed with us in England the previous year. At that time, the Fochs had homes in Paris, La Flèche, Pont-à-Mousson and Angmering in West Sussex.

Several of these houses had been presented to General Foch after the First World War as a way of thanking him for halting the German advance at the Marne in 1914. In 1918 he became Supreme Commander of the British, French, and American armies and dictated the terms of the Allied victory.

Madame Foch, whose husband, the General's son, had been killed in the Second World War, worked hard to provide for her family. The children had their friends and interests, which meant that the job of entertaining me fell largely to General Oudenon, Madame's widowed father, who spent

much of his time with his daughter and grandchildren.

Probably because he was bored, and possibly lonely, the old man set out to teach me all he could about French and German military history. I was an eager pupil with a huge appetite for knowledge and I devoured everything he told me.

There was one topic, however, on which General Oudenon was implacable and that was the ownership of Alsace-Lorraine. The region, which bordered Germany, had been the subject of a long-running dispute between France and Germany. To illustrate that Alsace-Lorraine belonged to the French, the General would show me his stack of First World War postcards detailing the devastation of the region's historic buildings by, he insisted, the Germans.

This was curious because during the First World War Alsace-Lorraine belonged to Germany and had done so since unification in 1871. It was a subject about which the old General felt passionate and he never missed an opportunity to rant about how badly the Germans had treated the region and its people during the time they owned it. The French regained Alsace-Lorraine following the Treaty of Versailles in 1919, largely orchestrated, as mentioned earlier, by General Foch.

The story has a sequel, however. To complete my education in military history, the General insisted on taking me to Germany to show me the devastation inflicted by the Allied troops. I seem to remember that we went in a French military car with a driver, about which I felt distinctly uneasy since this was still only 1949. I recall us having a dreadful

time crossing the border, over the river Saar, spending a long time in the border guard's office waiting for the General's papers to be cleared. We were allowed to proceed only after a great many telephone calls and much heated discussion.

Aside from fuelling my love of military history, General Oudenon also sowed in me the seeds of a lifelong appreciation for Alsatian wines. He taught me how to read the labels, what to look for in a good bottle, and where the best vines grew. Both subjects have given me a huge amount of pleasure over the years.

Early Employment

I do not believe that it ever occurred to my mother to discuss the question of a career with her daughters. We belonged to the generation born before the Second World War and were brought up in the tradition of the old values. To quote from Hillary Rodham Clinton's memoirs *Living History*, 'we were trapped between an outdated past and an uncharted future.'

Except for a few 'bluestockings', women did not go to university. Even in 1963, only 10,100 women entered universities, compared to 64,604 (and that figure does not include the now defunct polytechnics) in 1993, thirty years later. So far as the girls of our acquaintance were concerned, the aim of most parents in the late 1940s and early 1950s was to get their daughters married as fast as possible, thus relieving them of the financial burden of their upkeep. The problem for parents was what to do with girls after they had left school

but before they got married. Paid work was one way of filling in the time before husbands and babies came along.

In our home, obtaining a job for me became my mother's most pressing concern. Each morning she would call in an urgent voice from her bedroom, 'Mary Ann, Mary Ann, come quickly!' I was reminded of the White Rabbit in *Alice in Wonderland*, who went on to say, 'Bring me my gloves this moment.' In my mother's case it was to exclaim, breathless with excitement, 'I have found the perfect job for you! Get your pen and paper and write as follows: "Dear Sir, I wish to apply for the position of lion tamer [or whatever was on offer that day], as advertised in *The Times*..."'

It was useless to plead that I did not want to be a lion tamer. My mother would override my objections with the determination of a woman nearing the end of her patience. In a final bid to stop the nonsense, I would appeal to her vanity. 'But what about the job of rabbit hutch cleaner that I applied for yesterday? You told me that that was the only job for me.'

'That was yesterday,' she would reply dismissively. 'In any case, the more I think about that job the more I think it would be entirely unsuitable. Quite apart from anything else, rabbit hutch cleaners are such common people.' This was the *coup de grace*. Being common was the most damning condemnation my mother could confer on anybody.

In those days jobs for the unqualified were advertised in the Personal column of *The Times*. Since I did not have any skills to offer a prospective employer, the choice was

generally confined to jobs of a domestic nature. Assistant matrons and mothers' helps were the favourites. Both situations were residential, thereby avoiding the awkward subject of flat sharing, a mode of accommodation not favoured by my mother. And so we went on, clutching at any straw *The Times* had to offer.

Eventually, I secured a job as an assistant matron at Christ Church Choir School in Oxford. Miserably unhappy, through no fault of the school's but because I was a very square peg in an oblong hole, I managed to last an entire term before deciding to move to London, where I had been spending most of my free time anyway.

London

Many young girls have been attracted by the idea of the bright lights of London. For me, however, moving there in the mid-1950s was not a flight of fancy but the start of a love affair that has lasted a lifetime. Doctor Johnson was right when he wrote, in 1777, 'When a man is tired of London, he is tired of life; for there is in London all that life can afford.' A maritime city, with an ancient history, the shrill cry of seagulls reminds Londoners that it is built on an estuary and that the sea, from the City of London, at least, is closer than a bosun's whistle away.

There were two obstacles to overcome before I could finally persuade my mother to allow me a trial period in London. Firstly, where could I stay? Secondly, what could I do? Eventually, she allowed me to enrol at the Lucie Clayton School of Modelling, financed by a loan from Andy, which was to be repaid following my first job. My first job only

lasted one week, however, so repayment was destined to be slow.

My contemporaries at the Lucie Clayton School of Modelling included Tania Mallet,* who became the murderous Tilly Masterton in the 1964 Bond film *Goldfinger*, Jean Shrimpton, Celia Hammond, both of whom became supermodels, and Sandra Paul, who had the distinction of appearing on the front cover of American *Vogue* for two months running.

I secured a position as a house model with a clothes wholesaler in East Castle Street in the West End. Couture it was not. The house model I was to replace was, surprise surprise, Sandra Paul, one of my trainee modelling companions who had been sacked. She had been there one week, and it was also her first job. Like Sandra, I too lasted a week before being asked to leave. We were both too thin to model wholesale clothes, which were sizes 12–14; we were both size 8.

An unknown at that time, Sandra later became a top model and married Michael Howard, Home Secretary in John Major's Conservative government. We overlapped for a day, during which time she was supposed to show me the ropes. Not an easy task as the clothes we were modelling had to be yanked in with clothes pegs to look as though they fitted us. We were also both too inexperienced to cope with the primitive working conditions of the time.

Our rest room, in which we ate a sandwich for lunch, was

* Tania Mallet, born 1941; died 2019.

a cupboard so small that we were obliged to sit on facing stools with our legs stretched up the walls at either end. My memory of Sandra was that she was fun, knew exactly where she was going, and made my first day at work bearable, even if the remaining four days were less so.

The fashion scene of the late 1950s was dominated by the statuesque divas of the modelling world. The legendary Barbara Goalen may have been in the twilight of her career but Bronwen Pugh (Lady Astor) and Anne Gunning (Lady Nutting) were in their prime. I was to meet Anne Gunning later in my career (see Chapter 27). They were succeeded by Fiona Campbell-Walter, a great favourite of Cecil Beaton's, who later married Baron von Thyssen.

As is the case now, models had to be tall to do catwalk work. London fashion houses like Susan Small, a misnomer if ever there was one, were looking for girls of 5ft 10ins-plus which, as I stand just under 5ft 7in, was bad news for me. Although there was plenty of other work to be had, such as modelling for less exclusive magazines and brochures, glamorous it was not, and photographic modelling was still in its infancy.

I was fortunate to be taken on as a house model by the leading milliner Simone Mirman[*] at her famous salon in Chesham Place. She was a great believer in the partnership between hat and personality and I think she found that my structural facial features were a rewarding challenge to work around.

[*] Simone Mirman. Born 1912, died (France) 2008.

Madame had learnt her trade with the legendary Elsa Schiaparelli* at her salon in Grosvenor Street, W1, and counted members of the Royal Family as clients as well as the actresses Vivien Leigh† and Valerie Hobson.‡ She also worked with the leading couturiers Sir Hardy Amies, Sir Norman Hartnell and her fellow countryman, Christian Dior, making hats to complement their collections.

For some curious reason clothes coupons during the War were not required for hats, so everybody had one made, their only concession to frivolity, and this was one aspect of the fashion industry which increased in production. The milliners had a field day and Simone Mirman was kept busy throughout the Second World War making hats for a growing clientele.

Madame was always very generous with her gifts of hats to me although, truth to tell, the hats usually looked much better on my mother and, to her delight, many of them in their smart black and white hat boxes, with Madame's name written across the lid, ended up in her wardrobe. This elegant photograph of my mother shows her proudly wearing one of Simone Mirman's most expensive creations.

* Elsa Schiaparelli, Italian fashion designer. Born 1890, died 1973. Opened London boutique in 1933. Clients included the Duchess of Windsor.
† Vivien Leigh. Born 5 November 1913. Died 8 July 1967. British actress. Married to the English actor and director Sir Laurence Olivier OM.
‡ Valerie Hobson. Born 14 April 1917. Died 13 November 1998. Irish-born actress. Her second husband was John Profumo, a government minister who became the subject of a widely-reported sex scandal with the model Christine Keeler.

Later, I moved to 16 Motcomb Street to work for her arch-rival and fellow countrywoman, the French milliner Jenny Fisher.* I am sure that Simone Mirman saw this move as an act of betrayal although she had relented sufficiently to make me a ravishing hat, which she presented to me when I got engaged in 1961. Jenny outrageously poached me with the promise of more money and, more importantly, more fun, especially as she was making hats for several of the guests invited to the wedding of Princess Margaret and Lord Snowdon in 1960.

Jenny's husband was the jeweller Michael Gosschalk,† who had a jewellery shop a few doors away at 20 Motcomb

* Jenny Fisher (Gosschalk). Born 14 March 1925. Died 30 November 2014.
† Michael Gosschalk. Born 28 October 1923. Died 13 December 2010.

Street, SW1 and, although I could not afford to buy any of it, my interest in his and Andrew Grima's beautiful designer jewellery was probably sparked at that time.

One legacy from my desire to model is the excellent physical training that the pupils were given at Lucie Clayton. I still do many of the exercises to this day and cannot hear the song 'Catch a Falling Star' without spontaneously breaking into the tummy-toning routine we all learnt.

During this period, I stayed with an elderly lady in Egerton Terrace called Mrs Manley. A letter sent by my mother in answer to an advertisement placed by this good woman in *The Times* requesting a paying guest had yielded a satisfactory response and I duly moved into my new lodgings within the month.

Mrs Manley had an Irish maid called Phyllis, who was about my age, and proved to be an invaluable friend, often leaving the back door unlocked so that I could sneak up the backstairs after a party, thus avoiding the tricky problem of tiptoeing past Mrs Manley's bedroom in the early hours of the morning.

Although she was in her 80s, Mrs Manley was a serial party raver and liked nothing better than to take a group of her tenants to the Berkeley, when it was at its old site on Piccadilly. Phyllis Court at Henley was another favoured spot. My attendances at these events were limited both by the cost and the fact that they were usually very boring.

To supplement her precarious income, Mrs Manley gave French lessons. Her students were mostly young men who

needed the language to further their careers. It meant that there was much activity at the house at all hours and one never knew whom one might meet on the stairs.

I suppose it did occur to me that my landlady might be considered somewhat 'rakish', but I did not give it much thought. A visit to my cousin, Prue, who lodged a little further down the Brompton Road, was responsible for bringing my stay with Mrs Manley to an end, although I was rather sad, as I had enjoyed the buzz at Egerton Terrace.

Prue's elderly landlady, Miss Pleasance Pratt, considered Mrs Manley's establishment entirely unsuitable for a young girl and threatened to write and tell my mother. She showed me some ancient newspaper cuttings proving that Mrs Manley had been a notorious swinger in her day. 'A leopard does not change its spots,' muttered Pleasance. 'You had better come and stay with me.' So, I did.

Pleasance was a formidable landlady and, when she issued an order, we all jumped to obey it. She had a number of lodgers and took a keen interest in each and every one of them. Undoubtedly autocratic, she was also one of the kindest, most far-seeing and democratic people I have ever met. Two conflicting characters in one body. Extraordinary.

In looks she bore an uncanny resemblance to the actress Margaret Rutherford, especially in her role as the companion to Lady Bracknell in Oscar Wilde's *The Importance of Being Earnest*. Her voice was deep and very clear. At night she slept, if she ever did, with her bedroom door wide open and, no matter what the time, heard every girl come in. She

would then insist on a detailed account of their evening before allowing them to go to bed.

Pleasance lived in a large mansion flat above the one occupied by the Slade family. Julian Slade, the middle son, had already composed and written the lyrics (with Dorothy Reynolds) to the musical *Salad Days*, which was running at the Vaudeville Theatre in London to enormous acclaim. He was to follow this success with *Free as Air* in 1957, which ran at the Savoy, and *Follow that Girl* in 1960, which opened at the Vaudeville.

Pleasance occasionally went to tea with Mrs Slade and although I was once roped in to go with her as, according to Pleasance, I was 'idling away an afternoon', I never got to meet Julian.

All the flats were above a grocer on the corner of Brompton Road. Handy for Harrods, which none of us could afford, and particularly good for buses that went nowhere near where any of us wanted to go. Two changes in both directions was normal.

In February 1958 I moved from Pleasance Pratt and her flat in Brompton Road to 66 Limerston Street, the home of Yeo MacCarthy and her two young daughters and became a Paying Guest (PG) in Yeo's basement studio. I cannot remember how this introduction came about, but could it have been arranged through the trusted Personal column of *The Times* again?

Yeo had bought the house for £5,000 the previous year

from the politician Woodrow Wyatt* and his highly decorative girlfriend, Lady Moorea Hastings.† Yeo MacCarthy had been widowed in 1943 and she had brought up two small girls with the help of their nanny, Isa, who had her own bedroom in the basement area she now shared with me.

1958 was the final year that the Queen held debutante presentations, a system that had been in operation since the 18th century and which traditionally marked the social emergence of young ladies from the schoolroom into adulthood. Fiona, the elder MacCarthy daughter, was to come out in this final year of presentations. She was a reluctant debutante and in 2006 wrote *Last Curtsey*, published by Faber & Faber, a book in which she recalled her season with part affection and part horror.

Social ease did not come naturally to her and so I suspect she did not enjoy her season with as much joie de vivre as she might have. I, on the other hand, being two years older than Fiona, with an already wide circle of friends, managed to enjoy many of the parties that Fiona went to, including her own dance at the Dorchester, on 10 June, a really lovely event.

Sally Croker-Poole was the 'Deb of the Year' in 1958 and I knew her reasonably well, or at least I thought I did. She married James Crichton-Stuart‡ in 1959 but the marriage

* Baron Wyatt of Weeford. Born 4 July 1918. Died 7 December 1997.
† Lady Moorea (Hastings) Black MBE, JP, 1928–2011, daughter of the 16th Earl of Huntingdon.
‡ Lord James Charles Crichton-Stuart. Born 17 September 1935. Died 5 December 1982. Brother of the 6th Marquess of Bute.

had obviously gone horribly pear-shaped by 1962. My by then husband, Oliver, and I arrived at a restaurant to have dinner with Jimmy and Sally. Jimmy greeted us but there was no sign of Sally. She simply never turned up. No mobile phones in those days. We waited and waited and then the three of us eventually ate dinner together with Jimmy upset and embarrassed. We did our best to cheer him up, but it was a hopeless task and we knew then that the marriage was doomed. Later, in 1969, she married His Highness Prince Karim Aga Khan, the 49th Ismaili Shia Imam, and became a Princess.

I know that Fiona looked back at 1958 with no particular joy, but I remember it as a very happy year and am grateful to the MacCarthy family for allowing me to share many of the behind-the-scenes moments with them and some of the highs and the lows. It was the year which marked the old world giving way to the new, and things on the social front might never be the same again, but reinventing oneself to adapt to change has always been the name of the game for survival, and 1958 marked that change for us all.

The Underground Party

There are good parties, bad parties and, just occasionally, parties that are so memorable they are proudly referred to by subsequent generations who were not even there.

In the spring of 1959, a young man dreamt up a plan for a party that was so audacious questions were subsequently asked in Parliament as to how it could have been allowed to happen, and no such event has ever taken place since. The young man wanted to give a party but had no money to do so. He therefore invited all his friends to bring a bottle (and they, in turn, invited all their friends to do the same) and board the first westbound Circle Line train leaving Sloane Square after 8pm.

Three carriages very quickly filled, and the most amazing drinks party took place. Everybody was extremely polite and the members of the public who were already on the Tube were very good-humoured about the jollity. Indeed,

England's answer to Brigitte Bardot was seen sitting on the lap of a bemused clergyman as the train ground to a halt at Westminster.

At each station guests got out and joined the party in different carriages. It was, the young man said later, 'rather like moving the entire contents of The Antelope pub [a well-known watering hole in Eaton Terrace] into another pub.' There was no bad behaviour, apart from one arrest (and that was in the middle of Sloane Square) but it is fair to say that nobody was quite sure how many times they went around the Circle Line!

I was escorted to the party by somebody who knew the resourceful young man. We did not stay very long, and in any case our host was surrounded by partygoers. The man's name was David Wingfield. Who could have known that many years later we would marry?

Africa

In 1960 I became engaged to Michael Moore and went to stay with his mother and stepfather, the Southbys, in what was then Southern Rhodesia.

The journey was undertaken in a de Havilland Comet, the world's first commercial jet airline, which belonged to BOAC (British Overseas Airways Corporation). The plane made stops in Rome, Khartoum and Nairobi, flying over Mount Kilimanjaro with what seemed like inches to spare. The Comet could accommodate eighty passengers (but only about sixty seats were taken on my trip) and the toilets were coyly described as 'powder rooms'.

The comedian Frankie Howerd OBE (1917–1992) was also a passenger on the journey to Salisbury (now Harare) but whilst I was full of wonder (it was the first time that I had flown in a jet-propelled aeroplane), he was full of fear,

running up and down the aisle of the plane, which was somewhat unsettling for the other passengers.

Howerd had good reason to be fearful given the Comet's safety record, or lack of it: from 1953 it suffered thirteen crashes, resulting in 426 fatalities, and, although we could not know it at the time, this led to the Comet being retired by BOAC in 1964.

Despite the distressing teething problems, the Comet was a revolutionary advance in aviation. With its Roll-Royce engines and aluminium fuselage it flew faster and higher than earlier propeller-driven aircraft, reducing journey times and improving comfort.

In the year that I travelled to Southern Rhodesia, de Havilland was bought by Hawker Siddeley which, in turn, became part of BAE Systems. I count myself as very privileged to have been part of this evolutionary aviation success. BOAC became British Airways in 1974.

My time with Michael's family was largely spent on his parents' farm in Bulawayo, where they grew tobacco. One of the many highlights of the trip was visiting the tobacco auctions, which took place in the capital, Salisbury.

The bidding was extremely rapid, and it was hard to understand the auctioneer's language but if you listened carefully you could hear snippets of non-auction speak woven into the patter, such as 'There is a very pretty girl standing in the red aisle by the bales from Bulawayo.'

At that time the political situation in Southern Rhodesia was hugely unstable. Roy Welensky was the Prime Minister

and the Governor-General was Lord Dalhousie, who came to stay at the farm on a private visit. Dick Southby* was an MP, so we had many of the movers and shakers of the political, legal and financial world come to visit.

It was on one of these visits that I sat next to a very eminent African lawyer who told me that unless the African people could be educated to form a large middle class they would never be raised from the level of peasants. This was not, of course, rocket science; I heard the same comment applied to China when I was in the Far East, but it was quite prescient in 1960 when there were very few middle-class Africans working in Africa.

At the time of my visit, each farm in Southern Rhodesia had a number picked out in 10ft white digits, usually sited on the lawn or as close to the house as possible and designed to be seen from the air in an emergency. There were strict rules about what the inhabitants could or could not do to help preserve their safety.

It would be true to say that the atmosphere was jumpy. The owner of the farm next door, some five miles away, was chopped up as he slept under his mosquito net. We never knew for certain who might be next. It was distinctly unnerving to lie awake at night listening to the revellers on the farm compound celebrating their end-of-the-week pay

* Lt Col. Sir Archibald Richard Charles Southby, OBE, 2nd Bt. Born 1910. Died 1988. Married, in 1947, as his second wife, Olive, formerly wife of Gen. Sir James Newton Rodney Moore GCVO, KCB, CBE, DSO, the mother and father of Michael Moore. The Southbys had a son, born 1948, who succeeded his father as 3rd Bt in 1988. Dick and Olive Southby divorced in 1964. Olive died in 1991.

packets with chanting and shrieking. I can well imagine how frightening it must have been for those soldiers from the Welsh valleys who may have heard similar cries during the Zulu War.

The four months I spent in Africa did not make me an expert in either the political or economic situation of the country, but I learnt much about both, for which I will always be grateful to the Southbys. Perhaps, more than anything else, I learnt to recognise the all-pervasive smell of fear, and to understand that fear and uncertainty go together and that neither is good for the human soul.

Michael and I decided to terminate our engagement (it turns out that Michael had found companionship else-where) and whilst I left Africa with a heavy heart it was also with a spirit of optimism for what the future might hold. Back in London I took a long hard look at my options. Was it too late to go to university? Had I any chance of being accepted with the limited number of exams I had acquired such a long time ago?

On the face of it the answer was clearly no, but I had two valuable weapons in my armoury. My aunt Vaire's first husband, Douglas Logan, and his second wife, Christine, had become good friends of mine when I had first come to London. He was Principal of London University and had recently been knighted (1959).

Douglas was very keen to support my application to read archaeology; it was also fortunate that archaeology had recently become a university subject. Better still, Douglas

was a good friend of Professor W. F. Grimes, who was the then director of the Institute of Archaeology and Professor of Archaeology at the University of London.

Professor Grimes had discovered the London Mithraeum, a Roman temple to the god Mithras, which he unearthed during rebuilding work on a bomb site near Mansion House in 1954. In 1960 he discovered me, becoming my good friend and mentor. I still have his letter offering me a place to read archaeology at London University in 1961, although I never took it up, preferring to accept Oliver Baxter's offer of marriage instead.

Marriage

On 21 June 1961 I married Oliver Baxter. I am not sure why I did this except that it seemed like a good idea at the time. He was openly unfaithful during our engagement and throughout our married life, which I chose to ignore even when my nervous system staged a rebellion and I developed shingles on my head and face just before the wedding, so that I looked a fright going down the aisle.

Our best man was Christopher Norman-Butler who, although he had been at Eton and Cambridge with Oliver, confided to me much later that he was surprised at being asked to be his best man since they had never been close. Christopher had survived an attack of poliomyelitis* with only slight side-effects, contracted during an epidemic at Eton just after the War.

* As had Anthony Armstrong-Jones, who later married Princess Margaret in 1960.

At that time Etonians were still swimming in the Thames and the appearance of a dead airman floating in the river amongst them did nothing to alert the authorities to the unseen dangers lurking in the water. As Oliver later said, 'The airman incident was just part of everyday life then.'

Of course, he exaggerated, but not a lot. We ourselves swam in the river whilst we were at school at Sydenham House, but being in the depths of the country, we had nothing more exciting to contend with than a few cow-pats. An airman, dead or alive, would have been a welcome diversion.

Very few schools could afford swimming pools then, but Eton built a massive one shortly after the poliomyelitis outbreak. Oliver managed to get me access to this pool during the summer of 1963 and I was able to swim there whilst pregnant with our daughter, Emily.

Christopher Norman-Butler became a good friend of mine and remained so until his early death in 1994. His father, Edward, was a partner in Martins Bank, an old institution which originated in Liverpool, and which was taken over by Barclays in 1969. After my father died in 1996, I found a letter written by Edward Norman-Butler to my grandfather, dated 10 June 1947, amongst his possessions.

Clearly, Edward Norman-Butler would have had no idea in 1947 that his son would be best man at the wedding of Sir Gerald's granddaughter in 1961, so the letter is poignant. He writes to thank my grandfather for identifying a coat of arms and goes on to say:

I have just been looking up our old records to see your own family's early connection with us. As I told you, no books survive before 1731 although the Wollastons were probably banking with the Grasshopper [the logo for Martins Bank was a grasshopper] well before then.

In the Christmas Trial Balance Book of 1731, there are the following entries:

Fra (Francis) Wollaston Credit £235.3.7

Nicholas Wollaston Credit £106.9.1

William Wollaston Credit £190.5.7

Fra Wollaston also had £52.10s in the 'Notebook' and Nicholas (Wollaston) £15.

The then partners signed the Trial Balance, and this one is signed by Richard Stone, who was my own great-great-great-great-grandfather.

Yours sincerely

Edward Norman-Butler

The letter was sent from Martins Bank, 68 Lombard Street, London EC3 and, as an historical point of interest, the telephone number was Mansion House 6568 in 1947.

It was gratifying to note that my ancestors' accounts were all in credit, unlike their descendant, 250 years later, with her more or less permanent overdraft.

My grandfather had pencilled in the margin of the letter he then forwarded to my father that Francis Wollaston of Charterhouse Square, London, was my father's great-great-great-grandfather. His brother, Nicholas, was believed to

have lived at Glenhill, which I think very unlikely since it was not built until around 1857; William, another brother, lived in Suffolk.

I am slightly mystified by my grandfather's pencilled notes but would be loath to argue the point with probably the greatest living authority, at that time, on genealogy – especially his own! Referring to the family tree (his), I can see that William (1693–1757) and Francis (1694–1774) were indeed brothers but I can find no trace of a Nicholas Wollaston anywhere.

William Wollaston inherited the family estate at Shenton in Suffolk and lived at Fimborough Hall. He also had a house at 9 St James's Square, London SW1. His son, another William (1731–1797), was obliged to sell Fimborough Hall and the Stowmarket estate (but fortunately not the Shenton estate) in 1791 to a Roger Pettiward, to meet his gambling debts.

The story goes that when William's luck returned and he recouped his losses, he asked Pettiward to sell Fimborough Hall back to him. When Pettiward refused, William replied: 'Then you are no gentleman!' to which Pettiward responded, 'I know I am not, but I damn soon will be!' There is a portrait of William Wollaston by Thomas Gainsborough in Ipswich Art Gallery.

When Christopher Norman-Butler upheld family tradition and joined the staff at Martins Bank as a trainee he asked me whether I would leave my bank, the National Provincial, to become one of his first customers. At that

time neither of us had any idea of my family's already long connection with Martins Bank, as both my grandfather and Edward Norman-Butler were dead. I remained with Martins Bank until the takeover in 1969, and with Barclays Bank ever since, thereby keeping a family tradition.

On the day of the takeover, Christopher presented Emily, my daughter, who was also his goddaughter, with the Grasshopper model off his desk. She has it to this day.

Becoming a Property Developer

I started my property career in 1962 with an innovative little company called London Household Service Ltd (LHS), which I formed with my then husband, Oliver. The offices at 51 Beauchamp Place, SW3 were a hive of activity and there was often a row of smart white minivans, with the company name picked out in blue, parked on the street outside.

Across the street at 20 Beauchamp Place was a photographic studio called Thynne & Townsend, which was started in 1960 by the society photographers Philip Townsend[*] and Christopher Thynne.[†] Christopher Thynne had been

[*] Philip Townsend. Born 27 June 1940. Died 26 April 2016. Known as 'Mr Sixties', he photographed the Rolling Stones and Elizabeth Taylor with Richard Burton and many other stars in a series of black and white photographs which have since become collectors' images. His work is held in the V&A, South Kensington.

[†] Lord Christopher Thynne. Born 9 April 1934. Died 27 January 2017.

at school with Oliver. He was a talented photographer, especially in black and white – had he been more focused and organised, he might well have become a leading light in the industry. As it was, the studio only ran for a short time in the whirlwind era of the 1960s.

Fortunately, Christopher shot some pictures of me in 1962, as a private commission, before the studio doors closed, and I have chosen to feature one of the portraits on the cover of this memoir, partly because it is timeless in its composition and partly because it reminds me what a very good photographer he really was.

LHS was a company which was funded by subscription to provide a one-stop building and emergency service for its members. Similar 24-hour emergency services were successfully running in both New York and Ottawa at the time

IF YOU LIVE IN A LONDON HOUSE OR FLAT JOIN THE L.H.S.

DIAL KNI 3721 (9 lines) FOR:

- DAY AND NIGHT SERVICE FOR ANY HOUSEHOLD EMERGENCY.
- ALL CARPENTRY, ELECTRICAL AND PLUMBING REPAIRS.
- PAINTING AND DECORATING.
- NEW BUILDING, CONVERSIONS AND SURVEYS CARRIED OUT WITH THE SERVICES OF RECOMMENDED ARCHITECTS, IF REQUIRED.
- COMPETITIVE QUOTATIONS THROUGH RELIABLE INDEPENDENT CONTRACTORS FOR LARGE JOBS.
- CLEANING, LAYING AND DYEING OF CARPETS, CURTAINS AND SOFT FURNISHINGS.
- UP TO 10% CASH DISCOUNT ON MOST BRANDS OF HOUSEHOLD FURNISHINGS, FITTINGS, CARPETS AND ELECTRICAL EQUIPMENT, AND MANY MAKES OF MOTOR CAR.
- LARGE INSURANCE DISCOUNTS FOR L.H.S. MEMBERS THROUGH LLOYDS BROKERS.
- WINES AND SPIRITS AT WHOLESALE RATES.
- FREE DELIVERY OF HIGHEST QUALITY L.H.S. PAINTS AT SUBSTANTIALLY BELOW NORMAL RETAIL PRICE.
- RECOMMENDED FURNITURE REMOVAL AND STORAGE FACILITIES.
- PROFESSIONAL ADVICE ON INTERIOR DECORATION.

A telephone call ensures prompt, efficient service and advice for your particular household problem.

A mini-van service attends speedily to plumbing and electrical emergencies.

For any job you're freed of the burden of finding the right firm or man.

The L.H.S. is to flat and house dwellers what a motoring association is to car owners—a complete service that not only takes the worry out of owning or renting a house or flat but also saves you money.

From mending a fuse to converting a mansion the L.H.S. gets you good value quickly.

Don't Wait for trouble join today by mailing the strip on your right. Business premises by negotiation.

LONDON HOUSEHOLD SERVICE
DAY AND NIGHT EMERGENCY SERVICE
All householders' problems — One telephone number

but, according to a *London Evening Standard* article dated 24 October 1962, Oliver and I had further developed the idea by offering a wider range of building services.

The subscription was two guineas per annum by crossed cheque, or 35 shillings if a customer paid by banker's order. It entitled members to telephone (there were nine lines at Knightsbridge 3721) at any time during the night or day and receive an electrical or plumbing service to deal with whatever emergency had occurred.

The emergency service, with its eye-catching fleet of radio-controlled minivans, was certainly not a gimmick but it was the building and refurbishing work the company also offered which really kept our team occupied and in profit. With builders on hand it was only a small step for me to find, and do up, my first property, which I did in 1963.

Although my initial response to buildings was intuitive rather than learned, I soon discovered what sold and what did not.

At this time Oliver and I were living in a top floor flat in Earl's Court Square SW5, which, in those days, was not at all smart. I found a very rundown house full of bedsits in Warwick Road, close to where we lived, which I persuaded Oliver to buy since he had far more money than I did. It was a rewarding project, financially for Oliver and fulfilling for me.

I kept the house as bedsits, which was entirely appropriate for the area, but modernised the plumbing, electricity, and common parts, painted each room, replaced the worn-out furniture, and sold the house for a good profit. I was therefore able to persuade Oliver to let me do another refurbishment.

The next project was a house in Lonsdale Square, Islington N1, thought to be the only Neo-Gothic square in London. The Grade 2* listed square was designed in the 1840s by the church and college architect Richard Cromwell Carpenter, more famously known, perhaps, for building, or part building (as it was never finished), Lancing College in Sussex in 1854.

Lonsdale Square was, as he described it then, 'Well worthy of the attention of small capitalists desirous of availing themselves of … good home property.' The house I bought had obviously escaped the attention of a capitalist, however small, since it was very rundown indeed. A lot of work and

time was needed to pull it into shape. Eventually, it also sold very well, but it was not as easy a project to manage as the Warwick Road one, since it was in a part of London then unknown to me.

Lonsdale Square taught me to work in an area I was familiar with. I also learnt that houses with which you are in harmony work out better than houses with which you are not. If I were to say, however, that I work on 'gut feeling', it would carry no credibility. Indeed, when people ask why I made such and such decision I feel I must give them a logical explanation, but sometimes it really is hard to give a reason.

I have never met George Soros (an investor and philanthropist) but I am a great admirer of his and have read some of his books. I suspect that he is another entrepreneur who is motivated by temperament but required to give logical reasons for his success. Society demands an explanation for why he bought £2 billion worth of gold, for example, when investors were being told to leave well alone. He could hardly say, 'Well, I just had a hunch.'

Banks require borrowers to present them with watertight business plans for prospective projects, and I have had to learn to do this, if only as a disciplined exercise to back up a 'hunch'. Business plans rarely work, in my opinion, because they are based on too many assumptions. One of my mentors always said, 'If you want to succeed, assume nothing.' He was 100 per cent right.

Business plans assume that the rent will be such and such

in a year's time, or whenever the refurbishment is finished; the selling price will be such and such; the refurbishment price will be such and such and the building time will be such and such. This is risky, as property is a sector over whose fortunes one has very little control.

The only certain thing when you prepare a business plan for developing a property is the purchase price. The rest is assumptions built on expectations, and we all know how wildly optimistic these can be. On the other side of the coin, it is rare that a bank would lend solely based on a 'hunch'. I have had this happen twice in my life and in both instances neither the hunch nor the executive's belief in me was misplaced.

And the executives? One represented the Halifax Building Society and the other Barclays Bank, at a time when decisions were made locally and not by faceless committees. Both deserve to have had glittering careers – I hope that they did. And just in case you might imagine that either executive was spellbound by my feminine charms I should point out that one of the executives was a woman. Indeed, she was the first woman I had met in such a high-powered position. She had great insight, and I am still grateful to her for giving me her backing all those years ago.

The leveraging of equity is what, of course, masks the leverage of debt but providing that properties increase in capital value leveraging can be sustained. The property bubble which has grown larger and larger over the last few years has been built on this leverage and on cheap finance.

Now the bubble has a hole in it, which has released some of the gas. It will grow again, but not necessarily in a form that we recognise. Our problem is that we understand only known risks, and we do not always recognise a new risk until it is too late. Even then most risk can be minimised to some extent.

People's expectations also play a major role in the property market, the most common misconception of all being that the value of the collateral is not affected by the willingness to lend.

The Cookery School

In the autumn of 1964, for reasons I cannot now remember, Oliver and I went to live in Ferriers Grange, a large house in a hamlet called Hookwood, near Horley in Surrey. By this time, we had two small children, our son Charles having been born in September 1964.

The house needed a lot of work to make it habitable. To recoup some of the expenses of refurbishing it, we decided to open a cookery school staffed by girls from the Cordon Bleu culinary school. The school opened in the spring of 1965, as an article in the *Horley Advertiser* on 21 May shows.

Nobody was more surprised than me when it turned out to be a great success. After the first six months our bookings were up by a staggering 100 per cent and we were, at peak periods, reluctantly having to turn business away.

It was at one of these times that we had an enquiry about sending a cook to Newmarket to cater for a house party

Cordon Bleu cookery

NEW SCHOOL OPENS AT HOOKWOOD

With the changing pattern of modern living, entertaining in the home is very much on the increase, while with more people each year spending holidays on the Continent the taste for more variety in food is increasing.

When it comes to catering and cooking the words Cordon Bleu standard mean the highest standard of all, so many housewives—and perhaps others—will welcome the news that this week there opened at Hookwood the Baxter School of Cookery with a Cordon Bleu trained instructional staff.

The school has been started by Mrs Mary Ann Baxter at Ferriers Grange, the first house on the left on the Reigate-road past the junction with Horsehills and our reporter paid a visit last week to find out just why the school had been started.

Mrs Baxter said she was sure that many hostesses would be glad to know of those extra special dishes, garnishes and ideas that can turn everyday cooking into something a little more interesting.

Classes will be confined to not more than six persons at a time and will be held in the well-equipped kitchen where 20-year-old Miss Jane Riesco reigns supreme. She was trained in London where she took a year's Cordon Bleu diploma course.

Four pupils had enrolled for the first of the preliminary courses which began on Tuesday, and four more were due for the first of the advanced courses on Wednesday.

The preliminary comprehensive courses, which are held all day on Tuesdays and Thursdays for three consecutive weeks, are designed to give a sound basic knowledge of practical cooking and includes egg dishes, sauces, roasting, fruing, stewing, poaching, grilling, mousses, souffles, pates and most types of pastry making.

The advanced course, on Wednesday and Friday mornings for six consecutive weeks, is of special interest to those with a sound knowledge of cooking but who wish to prepare more advanced and original dishes.

Another course, on Wednesday afternoons for six consecutive weeks is one in cakes and patisserie and includes special English confectionery,

American cakes and Continental gateaux.

Every seventh week it is intended to run a Hostess Week from Monday to Friday all day. An intensive course, it is mainly for those who wish to entertain at home and may feel the need for new, stimulating ideas and methods for dinner, lunch and supper party menus. This course, however, has had to be postponed for a short while.

A special demonstration is to take place at the school today, Friday, when a party from Reigate Women Conservatives' Association will pay a visit to the new school. Similar demonstrations will be arranged from time to time.

Inquiries have already been received from housewives over a wide area but also from some catering establishments who want their chefs or cooks to improve their standards.

99

over the Guineas week in May. We had several weddings and parties already booked for this period, so I had to tell my enquirer that we would be unable to supply a cook and advised her to look elsewhere.

Later that day, Lady Derby, the hostess of the house party, rang me herself. 'I will not take no for an answer!' she said. I explained again, with great patience, that there was no one available for that week. 'Then come yourself,' she snapped. This suggestion had not occurred to me. True, I could not cook ... but how difficult could it be?

Later, when I tried to justify my decision to cook for Lady Derby to Oliver by saying that I 'owed it to the honour of the school not to let her down', he looked at me sadly and said, 'My dear, if the honour of the school is to rely on your culinary skills then we are certainly in all sorts of trouble.'

Armed with an arsenal of cookery books, I took the train to Newmarket. I do not propose to record the five days in detail, but it was certainly an amazing experience to see what life behind the green baize door was like before it disappeared entirely into history books.

Thanks to common sense, some decent recipes, and a brilliant ally in the form of the butler who helped me breathe life into the dying Aga, I survived, and more importantly so did the twenty-odd staff and guests I cooked four meals a day for.

Many years later, Emily, the little daughter I had left behind at Ferriers Grange while I fed the racegoers, went to stay with the Derbys in Liverpool. There, she met the butler who had

been so kind to me on my trip to Newmarket in 1966. They had a wonderful time discussing, to the accompaniment of peals of laughter, the immense effort it had taken us to get that first dinner on the table at Stanley House.

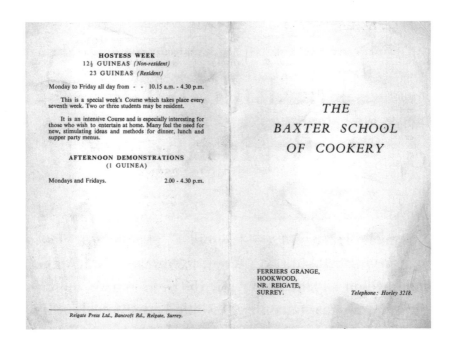

HOSTESS WEEK
12½ GUINEAS *(Non-resident)*
23 GUINEAS *(Resident)*

Monday to Friday all day from - - 10.15 a.m. - 4.30 p.m.

This is a special week's Course which takes place every seventh week. Two or three students may be resident.

It is an intensive Course and is especially interesting for those who wish to entertain at home. Many feel the need for new, stimulating ideas and methods for dinner, lunch and supper party menus.

AFTERNOON DEMONSTRATIONS
(1 GUINEA)

Mondays and Fridays. 2.00 - 4.30 p.m.

Reigate Press Ltd., Bancroft Rd., Reigate, Surrey.

THE

BAXTER SCHOOL

OF COOKERY

FERRIERS GRANGE,
HOOKWOOD,
NR. REIGATE,
SURREY. *Telephone: Horley 3218.*

The End of the Beginning

On 17 January 1966 I wrote a letter to *The Times* newspaper entitled 'Women Workers', which they published on 22 January. I wrote the letter to make a point, but I had no guarantee that it would be published or, if it were published, I had no idea that it would have the effect that it did. It touched a raw nerve and opened a floodgate of letters from women all over the country who were clearly unhappy that their efforts to return to work after marriage and children were frustrated at every turn.

This was interesting because from my own point of view, and living outside London as I then did, I was definitely considered to be something of an oddball by the yummy mummies of Surrey when I chose to commute to London to work at the *Sunday Times* rather than play tennis with my

WOMEN WORKERS

Sir,—You tell us (in "Notebook", January 10) that the National Plan calls for 200,000 more women workers. May I suggest that its call is neither loud enough nor helpful enough. It should lead as well as call.

At the moment a professionally unqualified woman, even though she may be a graduate and have run a business before she married, can expect to be offered little more than voluntary work or domestic jobs.

The Government's attitude would suggest that, because of the current low unemployment figures, its exhortation to us married women to return to work is just cant.

It doesn't surprise me at all that more married women don't go back to work. No encouragement, a job with no prospects and next to no money: this is surely enough to daunt the keenest woman.

I would suggest that if the National Plan really does want more married women to return to work, then it must see that far more is done to help and encourage them.

It takes four to 10 years to launch a family, and during this time one is a long-term prisoner in one's own home. This is a long time to be out of the swim, and although much is done to help criminals and rehabilitate them to the changes in the world after they are released, very little is done to help the married woman. She needs it, in my opinion, just as much.

Yours truly,
MARY A. BAXTER.
Ferriers Grange, Hookwood, near Horley, Surrey, Jan. 17.

neighbours. This community did not think it was right to go back to work after marriage and children and I remember feeling very guilty that I did.

At about the same time that I wrote my letter to *The Times* I entered a writing competition that the *Sunday Telegraph* had launched in January 1966. I did not win the competition and the £10 1st prize, but I was runner-up and my £3 book token from the *Sunday Telegraph* gave me the confidence to write more articles.

In February 1966 I found that I was pregnant again so

my call to arms to all women to return to work, when their children were sufficiently old enough, had to go 'on hold', temporarily, as you cannot fight nature.

The news of my third pregnancy also had a devastating effect on Oliver. He felt that he had made the mistake of marrying too young (which was true) and was being throttled by the responsibilities of marriage and children before he had had a chance to see the world. He wanted out, so we decided to close the cookery school and sell the house, while Oliver made plans to go abroad.

As it turned out my pregnancy was an ectopic one, which

meant that it had to be terminated in April. It was very distressing, as was the fact that, after the termination, I went on being pregnant and became very ill. Neither my local doctor nor my gynaecologist in London believed that I was still pregnant (there were, of course, no scans at that time) and, despite my tears, refused to take my pleas seriously. I imagine that they thought I was still experiencing a phantom pregnancy after the termination.

At the end of June, I dragged myself to Harley Street to see the gynaecologist who had terminated my pregnancy earlier in the year. I was now about five months pregnant. Once again, as he had done so many times before, he insisted that I could not be pregnant because he had witnessed the aborted foetus himself and it wasn't possible for me to have another baby on board. But it was, and he was wrong. I asked him to get a second opinion while I waited.

The second opinion came in the form of the life-saving Peter Jackson who sent me immediately to a hospital in St Albans. I do not remember how I got there but I do remember that I went straight from the Harley Street practice and there was no time to go home to say goodbye to the children.

When I came around from the operation (performed by Peter Jackson), there was a lovely priest sitting by my bed with a little table on wheels on which the last rites were prepared. Fortunately, it seems I did not need them, but we still went through the prayers together.

Several days later I learnt from Peter Jackson that my gynaecologist had been found dead in his Harley Street flat.

He was fifty-seven. The news was obviously very shocking, and the tabloid papers had a field day, since he was the darling of London society and much loved by all his patients.

The hospital at St Albans was brilliant, and I stayed there for just over two weeks. Friends came to visit, and my wonderful sister made several visits, a huge effort for her as St Albans was a long way to come without a car.

Oliver came to see me once (by car) and I studied the back of his newspaper for the entire visit. He did not return to the hospital to take me home after I had been discharged. He was busy. If I had not known it before, I realised then that our marriage was well and truly over.

Death of the Cookery School

We sold Ferriers Grange to a lovely couple called Andrew and Merida Drysdale in the summer of 1966. Almost immediately afterwards Oliver left on his world tour, having put all our furniture in store. I was too worn out to argue. It did not, I believe, occur to him that the children and I would need money to live on, and he made no financial provision for us whatsoever.

It was not for at least another two years that the courts were able to award a minimum maintenance of £4 per child per week, by which time Oliver claimed poverty on the grounds that he no longer had any capital or, indeed, a job. Without a salary, he could not pay child support.

What Oliver did do before he went abroad was to make an arrangement with the Drysdales that the children, the

two au pairs – Anneliese and Ingrid – and I could camp in their old house on Addison Road in Kensington, until it was sold. And camp we did, the Drysdales having taken most of their furniture to Ferriers Grange. It was obviously not an arrangement that could last for long, but it did give me a precious interlude in which to organise more permanent accommodation.

In the end, my beloved Aunt Jessie came up with a plan. 'How much money do you have?' she asked. 'I have £500 in savings from work and £500 which my father-in-law gave me when I married Oliver,' I said. 'That is not enough to buy a home for you and the children but it is a help,' Aunt Jessie replied. 'Find a decent house that needs no work for under £6,000 and I will put up the rest of the money. You must pray that I live for the next seven years or you will have to pay tax on that money.'

Even in 1966 it was a challenge to find a decent house that needed no work for under £6,000 in London but I was both determined and motivated. When I saw 17 Lillyville Road in Fulham, which was being sold by an architect and his family, I knew it was what I had been looking for. It had five bedrooms and three bathrooms, one upstairs, one downstairs and one en suite (thanks to the architect), which was unusual in those days. From our point of view, it was a palace!

After the architect had moved out, we did some light redecoration and moved in just before Christmas 1966. I loved the house, we all did – it had the most wonderful feel.

Aunt Jessie was not very happy about my choice, when I first told her, because at that time Fulham had a reputation for being rough and very rundown. It was also a long way from Knightsbridge, where she lived but, thank heavens, she paid up.

'What are the neighbours like?' she asked. 'They're a mix of working-class and aspiring professionals,' I said. 'I like them. The children and I will be just fine.' As I predicted, the three of us were very happy in Fulham. Charles started at Horder Nursery School and Emily went to Lady Edward's School in Redcliffe Gardens.

Anneliese went home to Germany in the spring of 1967 because, without an income, I could not afford two au pairs. A trained nanny, she had been with us for nearly two years and was brilliant with the children – strict but kind, which was exactly what they needed during that troublesome period.

Aged four and three, they were still very little. Ingrid had joined the household during the time that I was so ill, and she and Anneliese managed the house, the children, and the move brilliantly. Ingrid stayed on with us and I was so pleased. The children adored her.

I think I have established that 1966 was not a good year for me. To add to my woes, my close friend Angela Crammond announced that she and her husband, Tim, were taking the Australian government up on their offer of a £10 air fare to emigrate to Sydney. They were having a farewell party in London in July 1966 and I was in two minds as to whether

to go as I was not in party mode. I was also only just out of hospital, and still feeling quite fragile.

In the end, I did go, which was fortuitous for it was there that I met Charles Antony Harrison, who was to become my second husband, proving once again that out of bad situations silver linings do appear.

We talked briefly at the party, where my 'silver lining' told me that he was just about to leave Lloyd's and join a stockbroking firm. We did not meet up again for some weeks afterwards. I was busy finding a house and he, presumably, was busy adjusting to his new career.

Shoe Time

From the moment that my friend Angela Crammond arrived in Australia with her husband and family the previous year, her letters to me had been full of fun and happiness. I still could not understand what had possessed them to leave England for an unknown country so far away, so early in 1967 I decided to take up Angela's invitation to go and see for myself.

The problem was, I could not leave the children with Ingrid. It was too much responsibility for her to shoulder, however capable she was. By this time, I was beginning to see quite a bit of Tony Harrison and he came up with a solution. He would move into my house whilst I was away and ensure that all was running smoothly. I knew that I could trust him with my cherished children, but it also helped that he was a good friend of Angela's parents, Reg and Nancy Sutton, who would keep in touch.

The wonderful thing about Tony was that he made you feel you could achieve anything. After meeting him I discovered a sense of confidence I had not previously known I had.

In May 1967, after returning from Australia, I opened Footnote, a designer shoe shop at 4 Symons Street, just off Sloane Square in Chelsea. My original sales assistant was Christine and it is she who appears in the early photos of the shop.

I was very lucky to have some good friends in the fashion industry. Meredith Etherington-Smith* was very supportive and introduced me to her then husband Nick, who made slim, striped scarves for Footnote, which retailed at five

* Meredith Etherington-Smith. Born 30 January 1946. Died 25 January 2020.

guineas each and were an immediate sell-out.

Ernestine Carter,* who was enormously influential in the fashion industry at the time, gave me some excellent publicity. I knew her from my days working on *The Sunday Times* selling fashion advertisements. I was also friendly with Moira Keenan† who worked with Ernestine on the fashion pages. I liked them both, although Moira was much easier to work with!

Jean Kittermaster was another good friend. I had known her from our childhood days in Devon, when she was known as 'Binkie' Walker. She was a brilliant journalist and wrote some wonderful articles about Footnote. Indeed, we won a huge amount of publicity during our first two to three years of trading, and, as the designers were almost as lively and decorative as their shoes, the shop was always full of fun.

In the 1960s it was still common practice for ladies to order goods from shops on approval and then return them when and if they felt like it. If they did pay for them it was in their own time. This was, of course, a nightmare for retailers like me, as one had little control over cash flow and the debts could quickly mount up.

Tony was having none of this shoddy behaviour, however, and felt no embarrassment in marching round to Eaton Square, or wherever the address was, to claim back the shoes or demand a payment. He taught us that, in future, no matter who the customer was – and we had some famous

*	Ernestine Carter OBE. Born 12 October 1906. Died 1 August 1983.
†	Moira Keenan. Born 1933. Died 16th October 1972.

ones – if there was no money up front then there were no shoes.

I was extremely lucky to meet Andrea Pfister. Tony and I were in Bologna, Italy attending an important shoe fair where we hoped to find up and coming shoe designers to feature in our new London shoe shop. We were having dinner quietly in a restaurant, after a long day at the fair, when I noticed a glamorous-looking young man at the next table sketching a shoe. I introduced myself to him and his companion, Jean Pierre Dupré, and there began a very successful business association which blossomed into a friendship over many years.

Andrea and Jean Pierre had opened their own shoe shop at 4 Rue Cambon in Paris a few weeks before Footnote opened in London in 1967. Born in 1942, Andrea had already designed collections for Lanvin and Jean Patou in Paris and had shown his own first collection of shoes in 1965. He became our main designer and over the next fifty years made his name as one of the greatest shoe designers of all time.

I have always regarded myself as being very fortunate to have met so many inspirational people in my life, and Andrea Pfister was one of them. He died on 24 January 2018 at his home near Marseille in France, his partner, Jean Pierre, having pre-deceased him. His shoes are works of art and examples of his finest designs are on show at the Vigevano Footwear Museum in Italy.

In 1966 Julius Kunert[*] produced the Chinchillan hosiery yarn, an extremely elastic, supple, and transparent product with a silky shimmer. Footnote sold these new German-made Kunert tights from 1967 onwards and the Chinchillan tights dominated the market for many years, ensuring that Kunert became Europe's largest hosiery producer by 1979. The tights were the perfect accessory to show off our smart, designer shoes and to cover that newly exposed gap of bare flesh between knee and the hem of the new mini skirt.

Eventually, we outgrew the shop in Symons Street and moved to a larger showroom at 19 King's Road (opposite Peter Jones) in July 1969. The shop was designed by the architect Beverley Abbey and the interior designer Rosemary Hearn, working to a budget and 'motivated by those two happy gnomes Freeze and Squeeze', as our PR guru Madeleine Masson[†] archly put it. In other words, a tight budget but the effect was so wonderful you would never have known. Pure theatre!

[*] Julius Kunert. Born 1900. Died 7 February 1993.
[†] Madeleine Rayner (née Levy; 23 April 1912–23 August 2007), known professionally as Madeleine Masson, was a South African-born English-language author of plays, film scripts, novels, memoirs and biographies. Wikipedia.

Madeleine Masson was far more than a PR guru to me, and, to this day, I do not know why she chose to waste her time on a tiny account like Footnote when she was such a famous author herself. The fact that she did and that she and her husband, John Rayner, became very good friends of ours, was a bonus for us.

Malcolm Goddard rented the top flat above our show-room for £25 per quarter which seemed a fortune to us. The bid to rent the coveted first-floor flat was won by Andrew Downie, at the start of his successful career as an architect. He paid substantially more rent and a premium for fixtures and fittings but the downside of this bonus was that we were taken to court by a disgruntled under-bidder, who tried to claim that we were charging a premium over the rent, which was illegal at the time.

He lost the case because he was unable to identify *which* girl had shown him the flat, but it was a close-run thing.

By 1969 our team of designers had grown to include John Hlustik and Walter Steiger. We also pioneered the Footnote Boot Token, which was an inspired and successful present solution.

Although we were never short of publicity, the buying public still clung determinedly to their 'clumpies'. It was the Swinging Sixties, after all, and try as we might we could not seem to persuade enough people to buy our high-fashion styles.

Furthermore, we seemed to attract far more weirdos at our new premises than at the old shop in Symons Street,

where we had had a strong core of loyal clients. Perfectly respectable-looking City gentlemen would use our base-ment to change into ladies' clothes, which they brought with them in carrier bags. They would then spend hours trying on shoes from the shop to match their outfits.

They often came in groups of two or three. If we remon-strated with them for wasting our time, they became upset. Sometimes they bought the shoes which made everything worthwhile but very often they did not, preferring to act out their narcissistic fantasies in the secret world of our basement.

When we consulted the police (who were usually so good when we had a problem), they just shrugged their shoulders as no crime had been committed. In the end, annoying as it was, we had to go with the flow for the sake of our sanity.

We also had plenty of people who would try on shoes in the shop and then attempt to walk down the street in the new shoes, leaving their old 'clumpies' behind. On those occasions the police were wonderful. They arrived very swiftly, and we all joined in the chase down the King's Road to catch the thief, who was not always female.

Not far away, in Jermyn Street, Andrew Grima had just opened his designer jewellery shop, which Andrea and I would visit because we both found Grima's designs so inspiring. Like Andrea, Andrew Grima was a star in the ascendant, and I clearly remember, because we would com-pare trading notes, that there were days when both these fantastically talented designers found persuading the public to embrace their avant-garde ideas hard going.

In between the hurly-burly of running Footnote as well as Devon Smoked Foods Ltd in Fulham, a new business we set up in 1968, Tony and I decided that it was time for an away-day for ourselves. So, on 19 July 1969, we got married at the registry office in the City of London, with my sister, Ione, as a witness.

There is a hysterical photo of the three of us standing on the registry office steps after the ceremony. The lovely girls in Footnote had borrowed the flowers out of the window display to put in my hair (on the strict understanding that I brought them back after the wedding). I was thirty-two and Tony was fifty-one.

Edward Nightingale and MAW – look who's in the driving seat!

Above R: Crest of Edward VIII when Prince of Wales (see 'Family' chapter).

R and below: My grandfather, Sir Gerald Wollaston.

Riding instructions to me from my Grandfather – rather outdated now.

Your head & your heart keep boldly up.
Your hands & your heels down
Your knees keep close to your pony's side
and your elbows close to your side.

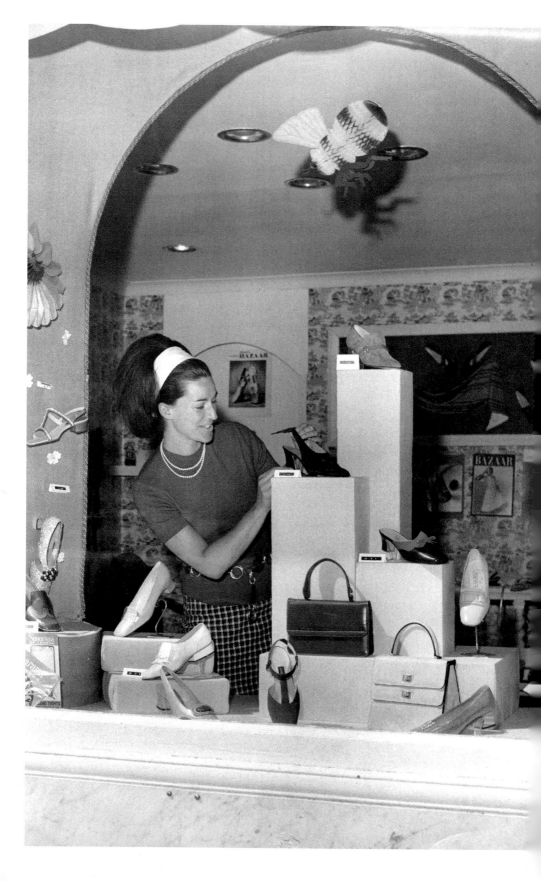

Andrea Pfister and
MAW in Footnote.

R and opposite: MAW
in Footnote shoe shop
at 4 Symons Street.

Footnote – Nick
Etherington-Smith's
scarf on the wall.

SPORT
and the
ARTIST

Volume 1: Ball Games

Mary Ann Wingfield

Southside March 1988

B A S E . .
HOOK LINE
AND SINKER

Wingfield
Sporting
Prints

35 Sibella Road,
London SW4 6JA,
Telephone & Fax:
071-622 6301

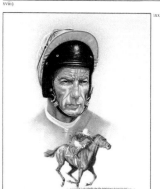

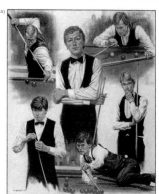

Opposite:
Top L:
Published by
ACC Ltd, 1988.

Top R:
Promotional
literature for an
exhibition at
the Wingfield
Sporting Gallery,
10 March 1988.

Below:
Limited edition
prints from
original painting
by Peter Deighan
for the Gallery.

Artist Peter Deighan and snooker player Steve
Davis at a signing session.

Lester Piggott signing a limited edition print of a painting by
Peter Deighan for the Wingfield Sporting Gallery.

L and below:
Ham House Stud,
Sussex, 1976.

Uncle Jack,
aged 92, going
fishing on Loch
Tay, Scotland.

The Pearly King of Peckham, Pippa Corbett, and Cicely McCall at the Queen Mother's 100th birthday parade.

Eric Evans, Dean of St Paul's Cathedral, London, who christened George Lee on Sunday September 1994 at Llangenny in Wales, with George's mother, Emily.

Lord Mayor Mr Alderman Clive Martin greets Miss Cicely McCall MBE, lunch at Mansion House, 11 July 2000.

Emily, Charles, MAW.

Mary Ann and David,
wedding, 17 June 1982.

MAW, Charlie, Laura, DRW and Zara
Lee (flower girl) at Charles and Laura's
wedding, 23 June 2001.

In 1972 a series of events made the decision to close Footnote a relatively easy one. Although we were making money, the overheads were eye-wateringly high, which meant that we were doing little more than scrape by. Property on the King's Road saw rocketing prices: a shop worth around £4,500 in 1950 was worth £30,000 in 1967, when I bought Footnote, and £45,000 by 1969. The rents rose at an even faster rate as the King's Road became a creative hub and fashionably cool by the mid 1960s. It was time to move on.

In addition, the cross-dressers in the basement were growing in number, which was becoming increasingly tiresome. How many transvestites did the City of London have, I wondered? I would never again be able to look at a man in a pinstripe suit without wondering what he got up to outside the office...

The increasing hassle of getting the shoes, which were made in Italy, through customs at London Airport was also proving a challenge. Contrary to expectation, the process was becoming more difficult with more paperwork just when it should have been getting easier with the dreaded purchase tax about to disappear in favour of the introduction of VAT in April 1973.

Finally, after five years of working every Saturday, which was our best day for trading by far, I decided that I wanted my weekends back to spend with my family. I could have left the shop in the hands of a capable manager, but I knew that would not work. The shop was very individual, and I

was that individual. People expected me to be there, and they did not like it if I was not.

At the other end of Sloane Square is Holbein Place and in 1968 Caroline Combe and her cousin, the Countess of Lindsey and Abingdon, opened a shop there called Buy and Large, a dress shop which catered for the larger lady. This was odd since Caroline was wafer-thin, but their shop was a great success and filled a void left by the numerous shops catering for the skinny adolescents further down the King's Road.

I knew Caroline because we had been at school together at Sydenham House, albeit she was two years older than me. When we met up again, in 1968, I found her rather shy approach endearing. She loved more than anything to bring her sandwiches across the square to the garden at 19 King's Road, when we moved there in 1970. Then she could relax and, to an extent, let her hair down.

In 1968, the same year that she opened Buy and Large, she married Oliver Colthurst, part of the family that owns Blarney Castle in County Cork and its famous stone, said to give the gift of eloquence to anybody who kisses it. A gift, I would have thought, rather wasted on the Irish who have always been blessed with an abundance of eloquence.

After I sold Footnote in 1972, Caroline and I went our separate ways and, sadly, I did not see her again before she died in France in 2011.

The Smokery

Devon Smoked Foods Ltd was an impulse buy, rather than a considered career move, but it had its own character-forming challenges and was enormous fun to run.

Tony and I had caught a salmon, a feat, even in those days, and sent it to be smoked by the quite famous smokery at Totnes in Devon. When it was ready for collection we made the mistake of going to collect it ourselves (we should have had it posted) and, in a weak moment, we were persuaded by the owner, John Shaw Jones, to buy the business.

Once the sale was agreed, the old boy could not have moved faster. One moment he was there and the next moment he had gone, leaving us with a dilapidated factory and half a ton of unsold smoked mackerel pâté.

Over the years, Shaw Jones had built up a good mail-order business, which became very busy at Christmas and Easter. For the rest of the year it was pretty dormant. What we

needed was some regular commercial orders, so we enlisted the help of the wonderful June Hicks Ltd, whose legendary saleswomen were based in Vauxhall Bridge Road SW1.

We experimented with a pilot scheme in South West London, Surrey, and Sussex, with the girls calling on supermarkets, delicatessens, hotels, restaurants, grocers and golf clubs in a bid to peddle our wares. The mackerel pâté was greeted enthusiastically, so we then introduced two new pâtés, salmon and venison, which sold well, too. Business began to look up, but we could not afford to take our foot off the pedal.

Once again, through her great press contacts and her catchy PR releases, Madeleine Masson helped us hugely, just as she did at Footnote.

Tony and I once did some sales pitches on a Saturday morning in Sussex under her eagle eye. My efforts were dismissed as pretty feeble, but I remember her, in despair, remonstrating with Tony about his abrupt sales technique.

She suggested, accompanied by peals of laughter from myself, that, 'Good morning, Mrs Pelly-Fry. Are you interested in some smoked mackerel pâté [lolling on the counter], I've got a whole load of it here,' might be better expressed as, 'Good morning Mrs Pelly-Fry. Can I interest you in placing an order for the delicious smoked mackerel pâté you enjoyed so much on my last visit?' Tony tried his best but was never destined to be top salesman of the year.

The next problem with Devon Smoked Foods Ltd was that all our new orders were from London and the South

East, but the Smokery was in Devon. Our faithful driver, Dougy, worked night and day, which obviously wasn't sustainable, and the team in Totnes, under the management of my sister, Ione, and her able assistant, Marion Gorin, were under huge amounts of pressure to meet all the orders.

As a solution, we found an abandoned food factory in Fulham and bought it together with two little houses, which flanked the main entrance. The entire package cost us £16,000 but of course both houses had sitting tenants in them and 'boy' were those tenants rough and noisy.

The Fulham factory was grim, but we worked hard to pull it into shape and employed two wonderful ladies, Mrs Dawkins and Mrs Cook, to gut and fillet the fish. A company called Marine Harvest provided the salmon, which we smoked and made into salmon pâté for Marks & Spencer.

The wonderful Annie Phillips joined the Fulham team as manageress in March 1970, and Mr Urch of the White Fish Authority ruled us all with a rod of iron. What, you might think, could possibly go wrong? Well, I will tell you…

Despite London's power stations belching out smoke from their chimneys – only a few had been decommissioned at that time – Hammersmith & Fulham Council kicked up a fuss about the smoke coming from our smokery, even though the amount was tiny in comparison to that of the power stations.

We should have known it was politically motivated. After all, nobody was asking Mr Forman in the City to close *his* smokery. Inevitably, the Council won and whilst we kept

the factory as a distribution centre for a while longer it soon became clear that having the Totnes smokery process our orders as well as their own was not going to work.

In the end we sold both sites. The timing was perfect since both Tony and I had been worried that should Marks & Spencer, our main client, pull out we would be left in a vulnerable state.

We sold the London site to Sir Anthony Nutting,* who wanted to turn it into a London home. In my opinion he should have pulled the factory down and started again from scratch because the problem with the finished result was that there were no windows at the back, which made the house rather dark and gloomy. It did not have a garden, either, as Sir Anthony used the courtyard at the front of the house to park his car.

On the rare occasions that I was invited to lunch or dinner I was greeted very formally by a butler, which I always felt was rather out of keeping with the area. On the last occasion that I was invited to lunch alone with Lady Nutting,† she told me how much she hated the house.

Privately, I rather agreed with her; shortly after that she died which, whilst there must have been other complications as well, only goes to show that she was not joking.

* Sir Harold Anthony Nutting, 3rd Baronet (1920–1999) was a British diplomat and Conservative Party politician who served as a Member of Parliament from 1945 to 1956. He was a Minister of State for Foreign Affairs from 1954 until he resigned in 1956 in protest against the Suez Invasion. Wikipedia.

† Anne Gunning (1929–1990) was an Irish fashion model. Originally a house model for Sybil Connolly, she gained global recognition after being featured on the cover of *Life* magazine in 1953. Wikipedia.

Operation Market Garden

At this point I should add a short chapter about Tony's background and military achievements. He was an extremely brave man and I was privileged to have been married to him. We were happy for many years until the marriage irretrievably broke down and we went our separate ways.

He was born on 18 March 1918 into a well-to-do Liverpool family and won a scholarship to Winchester, which in itself was quite a feat when many people struggled to pass the entrance exam to this leading academic institution. He then went up to Trinity College, Cambridge where he was an Open Exhibitioner.

Commissioned into the Royal Artillery, Army No. 75273, he spent the early years of the Second World War in

field regiments and in late 1942 was accepted for airborne duties. He joined the 1st Airborne Light Battery and, when it expanded into three batteries, became Commander E Troop No. 3 Battery. They were posted to North Africa in April 1943 and, after training, embarked for Italy, landing at Taranto where they fought as mountain artillery before being withdrawn for the European campaign.

In September 1944, in Dakotas flown by American pilots and in gliders, the 1st Airborne Division took off from Grantham, Lincolnshire for the Arnhem region with instructions to capture and hold the bridge crossing the Rhine.

Unfortunately, these instructions did not include a plan of what to do in the event of meeting two Panzer divisions, four battle groups, an infantry division as well as General Model,* then Commander in Chief of the German forces, none of whom were thought to be in the area but all of whom were at the bridge to greet them when they arrived.

Under the brilliant General Model (later, Field Marshal) the Allies suffered a sharp defeat: of the 10,000 airborne troops who landed, 1,130 were killed and 6,450 were captured, although the Germans paid heavily for their victory with 3,300 dead and wounded.

Tony was wounded in the stomach by a bullet on 18 September 1944 and, after the War, often recalled his

* General (later Field Marshal) Otto Model (1891–1945). The Third Reich's best defensive tactical Commander but, unlike Rommel, almost universally disliked by those who had to work with him. Model shot himself on 21 April 1945.

experience as follows: 'For those of you who have never been hit by a bullet' he would tell his astounded audience, 'the shock is very considerable. First, you receive a violent blow and the bullet enters your body when it is practically red hot. Then, as your body registers the shock, you pass out.'

This last, I always felt, was rather an anti-climax but he explained that it was the body's way, with help in his case from morphia administered by a medical orderly, of processing the shock. Fortunately, he survived both the bullet and the shock, but his stomach bore the evidence of the wound for the rest of his life.

The Battle had begun on 17 September. Tony was hit by a bullet on the 18th and sent to 181 Field Ambulance where he discharged himself the next day. By 21st September 1944, his troop position at Oosterbeek was threatened by an enemy infantry attack from the West which broke through the local defensive position.

I am indebted to the Pegasus Archive for the following tribute:

Captain Harrison, in the absence of any senior officer, organised a mixed party of infantry and held off this attack. He then proceeded to organise a counterattack against the enemy who had taken up a strong position in the Gas works to the west of Oosterbeek. Despite the strength of the enemy's position and of the very mixed composition of his own force, Captain Harrison leading the attack himself, successfully stormed the enemy position and drove the enemy back.

Then under heavy fire he organised a strong defensive

position around the Gas works which our infantry was able to hold against all attacks by the enemy. Captain Harrison, by his courage and personal example, undoubtedly was solely responsible for restoring a very dangerous situation. It was entirely due to his magnificent example and great powers of leadership that this attack succeeded. For his bravery and leadership, he was awarded the Military Cross.

After Tony died, on 14 August 1995, I was contacted by Philip Warner,* an outstanding military historian and, for thirteen years, the *Telegraph*'s peerless Army obituarist. Philip Warner wrote a military masterpiece for Tony's obituary with additional non-Army detail supplied by me. I hope that the obituary did Tony credit. It appeared in the *Daily Telegraph* on Thursday, 7 September 1995.

In many ways Arnhem was the pinnacle of Tony's life and after the War he became somewhat of a maverick, always looking for a battle to fight or a cause to take up.

Most of them were lost causes which sapped his energy and money but he had a presence and a phenomenal memory which made him an effective speaker on radio and television, particularly in 1968 when he was opposing the Agricultural Training Board which he considered inefficient and unfair. (Not dissolved until 2016.)

He had more immediate luck with the Egg Marketing Board, which he opined should be done away with in 1968 and it almost was – in 1971!

* Philip Warner. Born 1914. Died 2000. Military historian and author.

Perhaps he never really found the right role for himself and his talents in peacetime, and I think he remained unfulfilled for the rest of his life. General (later Field Marshal) Model has a lot to answer for and Arnhem was never far from Tony's thoughts.

As with many stories in this book this story has a sequel, albeit a rather sad one.

In June 1984 Tony Harrison wrote to ask if my then husband David and I would drive him to Arnhem for the fortieth anniversary of the Battle, starting on Thursday, 20 September, as he did not have a car and could no longer drive.

He would pay for our accommodation, which he would book himself, and we would supply the car, the driver and pay for the car ferry. It seemed a fair exchange. Tony and I had remained in friendly contact after our divorce in 1978 and, as David and I were very keen to learn more about this historic battle from a first-hand witness, we agreed.

On 16 September, my son, Charlie, had his twentieth birthday and we asked him if he would like to come with us to Arnhem. He was equally interested in learning about the battle. Tony was very keen to join the celebrations and to go to the reunion dinner on Saturday, 22 September. We were not invited but we were fine with that.

Tony had told us some time before our trip that he had been diagnosed with Parkinson's disease and was on medication, but we hadn't seen him for a few months and I do not think that any of us realised how ill he really was.

We arrived at Arnhem very late on the Thursday evening. Tony was already showing signs of wear and tear after the journey and we discovered that there was no accommodation or dinner booked for us, which set alarm bells ringing.

On the Friday he seemed to be more or less back to his normal self and keen to show us the battle ground and landmarks. We were armed with Holt's battlefield guide of Arnhem, which Tony said had 'glaring inaccuracies. They [Major and Mrs Holt] should have asked me!' so we had to make do with his memory. His memory had been exceptional but now, in 1984, it was showing signs of decline and he seemed confused.

Tony planned that he would meet up with his colleagues for the Airborne March, the world's largest one-day annual commemorative parade, join the celebrations and the reunion dinner on the Saturday evening. We would all go to the church service on the Sunday morning before driving back to England in the afternoon.

But none of this happened. Tony seemed happy to spend time on the Friday walking over the battle ground with us but seemed to be in no hurry to contact his colleagues, which we thought was very odd.

On the Saturday morning, when we met him for breakfast, he was in a strange mood. He refused to contact his colleagues, who were so close that we could hear and see them, and asked to be driven back to England immediately after breakfast.

So, here was a pretty kettle of fish. We had come all this

way and the main objective had not been achieved. But it was useless to argue. He was implacable and we drove him back to England.

I think that the memories all came flooding back to him and he did not feel that he could handle the emotion, which we understood. He never referred to the trip again.

As I write this in 2019, we have passed the 75th anniversary of 'Operation Market Garden', marked in September at Arnhem. So now it is thirty-five years since we made our own trip with Tony. 'Operation Market Garden' was the code name that Field Marshal Montgomery, commander of the 21st Army Group, gave his daring but doomed plan to end the War by Christmas.

The remaining survivors of the 30,000 British, American and Polish airborne troops who fought in 1944 are now in their 90s and this year, eight of them who made the journey to the Netherlands were driven by the Taxi Charity for Military Veterans.*

It was Field Marshal Montgomery who wrote in his own press release after the battle, 'There can be few episodes more glorious than the epic of Arnhem. In years to come it will be a great thing for a man to say, "I fought at Arnhem."'†

* Formed in Fulham in 1948.
† Issued on 28 September 1944.

Lloyd's

In 1972 I applied to become an outside Name at Lloyd's, which was the first year the company allowed women to do so. I was the third woman registered as a full Name and the first woman for my syndicate, who were Brooks and Dooley.

I did not have an agent, thank goodness, but I was at that time married to Tony Harrison, an ex-Lloyd's man, who had started a small broking syndicate himself under the larger umbrella of Norman Frizzell.

Tony was twenty years older than me and felt that I should have a further source of income, albeit funded through my property endeavours, in case I was left a widow at an early age.

With the benefit of hindsight, of course, nothing could have been more naïve, but Tony was from the old school of investors who did not understand the greed and dishonesty which was to beset the City during the coming years.

Besides, he had enjoyed the time he had worked at Lloyd's and wanted me to experience some of the close bonding that he believed held the industry together.

He also felt, with some justification, that his experience might prove invaluable to me as I negotiated my way around this strange new world. He still had a number of friends and close colleagues who were influential in the insurance industry. I was immensely fond of Tony and would have gone out of my way to please him although, in truth, becoming a Name at Lloyd's was not at the top of my list of personal ambitions.

All went well for the first few years with Brooks and Dooley but after a bit I began to make very little money, which was strange because most of the other Names I knew, who were with other syndicates, were making a lot.

I was puzzled by the fact that despite my agency having large reserves, which was one of the reasons we chose them in the first place, the underwriters were writing very small lines. Normally, a syndicate would only write very small lines if the underwriter was either nervous of the market conditions or if he knew that the agency had little or no reserves. So why the excessive caution?

I voiced my concerns to Tony. Yes, it was strange, he said, why not write and ask why. So, I did. Had Brooks and Dooley sent a reasonable letter back, I might have accepted their explanation, however flimsy, but they did not. It was quite clear that I was, in their eyes, that most annoying of all persons: a woman who asks questions. 'Do not worry

your pretty little head,' the message ran. 'Leave the managing to us but above all do not question what we do. Let us just say this, if we had written bigger lines for you, you would have made even less money than you have.'

I was very angry. I picked up the copy of my letter to them and their response and sent both to the chairman at Lloyd's with a short covering note which read: 'I do not like being brushed off in this rude and dismissive way. I think that they are hiding something. Please sort it out.'

Pretty swiftly I had a reply. Would I mind if Lloyd's sent somebody to inspect my files over the years regarding this syndicate? 'I would have no objection at all,' I said, 'in fact, the sooner the better.' Two men came on motor bicycles, studied, sorted, and removed such papers as they wished to copy and departed. Shortly after that, the shit hit the fan. The press had a field day and Raymond Brooks disappeared to Spain with (I believe) the remnants of the reserve fund.

I had absolutely no idea of the floodgates that would open when I asked my simple question but once the press was alerted many more corrupt and mismanaged syndicates were uncovered. In due course, there was a disciplinary hearing held by Lloyd's, to which I had to appear as a witness in the case against Brooks and Dooley. Five eminent QCs took part, and the proceedings were in a room at Lloyd's which had been transformed to represent a court and was no less awe-inspiring for that.

Meanwhile, since Brooks and Dooley was suspended, I had to join some new syndicates fast. This was no easy task

because if syndicates were successful there was no guarantee that you could join them. They simply did not have any more capacity to write.

Tony took advice and we consulted the league tables which tell anybody who wants to know how well (or badly) Lloyd's insurance syndicates have performed. Unfortunately, of course, past achievement is no guarantee of future success. The syndicates we chose, with some of the best past results, were run by Peter Cameron Webb.

For some reason we went through an agent called James Upton. I cannot remember whether we first met James Upton, who told us that he was an agent for Peter Cameron Webb and that his syndicates were high in the league tables, or whether we consulted the league tables first and found that we were obliged to go through the agent. Either way, it is not particularly significant to the story.

If the Brooks and Dooley saga had been a watershed it paled in significance to the saga of the PCW (Peter Cameron Webb) syndicates. In 1982 I was happily minding my own business when I heard that the syndicates, including all the ones that I had just joined, had been suspended pending further investigation.

I rang James and asked for an explanation. 'Christ, I did not know,' he said, and he genuinely did not. No help there, then. If your agent does not know what is going on, what hope is there? In due course James came back to me, by which time he had composed himself sufficiently to be able to give me a hastily prepared party line.

This was designed to fob off syndicate members who were beginning to pelt the agents and underwriters with stupid questions such as 'Were they going to get their money back?' As if.

Quite independently, I happened to know Adrian Hardman who was the underwriter of two of my syndicates. I did not know him well, but his daughter and my daughter were friends at school. Many years later, after the dust had settled and everybody was trying to move their lives forward after losing not only a lot of money but their faith in an establishment that had once been a beacon of honest and gentlemanly behaviour, he told me that the trouble with the system at Lloyd's, at that time, was that it was corrupt at the top.

The young underwriters who joined Lloyd's did what they were taught to do by the people they were apprenticed to. Whilst they may have realised that it was wrong to borrow money from the reserves, everybody was doing it, to a greater or lesser degree, so that, eventually, nobody thought it was wrong. Until, that is, they were caught.

I have always felt sympathy for the victims who have had to carry the can for the misdoings of others – think Nick Leeson and the Barings Bank saga in 1995. It is not that the victims were necessarily innocent, and some paid the price for their crime, but they were by no means the only guilty ones and many walked away free.

The Banking Crisis
1972–1982

1972–1982 was a grim decade in the financial world. Merchant bank after merchant bank went into receivership or administration. Some banks were rescued by other banks who promptly went into receivership themselves. The country was held to ransom by the trade unions and it was the decade of the three-day week and strikes.

Tony and I had bought a small equestrian farm in Sussex at the end of 1971 with twenty-one acres. This was mainly because I wanted the children to have the same benefits that I had had as a child of being brought up in the country and having animals to care for. The farm had to pay its way, so we decided to breed racehorses (yes, madness, I know) and I bought a stallion for cash to stand at the newly named Ham House Stud.

To help fund the purchase of the stud, and for trading advantages, we took a loan from a small bank in Pocklington, Yorkshire called Capital for Agriculture (Cap for Ag). About eighteen months after we took out the loan the bank went into liquidation and what was left of the bank, including our loan, which we could not repay without selling the stud, was eventually passed to the Anglo-German merchant bank William Brandt Sons and Co, in Fenchurch Street EC3.

Suddenly, we had a whole new set of Masters who were changing the original agreement (which we had made with Cap for Ag) to a whole new set of rules to fit their City of London structure and which we could not meet.

The new bankers did not understand farming and they did not want our loan either, which they had reluctantly inherited from the by now defunct Cap for Ag. Brandts, as they became known, were determined to find a buyer for our stud, make us pay back the debt we owed and get rid of us since, I think, we embarrassed them.

Despite our best efforts a sale of the stud was not forth-coming as the property market, in keeping with everything else, had fallen to the bottom of the pit. Then, just when everything was looking very black indeed, Brandts were themselves taken over by National and Grindlays and we had to start our negotiations all over again with a new set of bankers with very different ideas.

In 1965 National Grindlays Bank, as they were known then, had injected £2–3 million capital into William Brandt Sons and Co in return for a two-thirds share of the bank.

By the time that the property market had slumped in 1973 Brandts had sold their remaining third share to Grindlays and were fully owned by Grindlays, thereafter. For a short time, the merged banks became known as Grindlay Brandts until the Brandts name disappeared for good.

Lord Aldington* was a non-executive chairman of National Grindlays at the time of the purchase of the two-thirds share of Brandts in 1965 and became chairman of Brandts until the final takeover in 1973.

Peter Brandt, one of the founding family members of Brandts, was nominated MD of Brandts by Aldington over the heads of the five more senior remaining Brandt partners, including his own father, which did not go down that well at the time.

Much later on, in 1992, Peter Brandt made a record, now in the British Library, of his time in the banking world[†] and definitely made it clear to his interviewer that he thought that Brandts had been betrayed by Lord Aldington and manipulated into anonymity.

Be that as it may, my diaries at the time definitely record that we were dealing with Brandts at their London offices in Fenchurch Street, a few doors down the street from

* Lord Aldington (alias Toby Low) 1st Baron Aldington 1914–2000. Chairman of Grindlays Bank. Director of the Grindlays family banking company since 1946, following both his father and his grandfather. Became the youngest Brigadier in the British Army in 1944. Involved in the 'Betrayal of the Cossacks' at Lienz (part of Operation Keelhaul at the end of the Second World War) and won a record £1.5 million (plus £500,000 in costs) in a libel case in 1989.

† National Life Stories in partnership with the British Library. Peter Brandt. Interviewed by Cathy Courtney in July 1992 C409/70.

Grindlays, until November 1976, whatever Wikipedia say to the contrary about them no longer being in existence after 1972.

It was a very unhappy situation for us all and, over the next four years, we spent a good deal of time being summoned to endless negative meetings in London.

Meanwhile, and against all the odds, we were making a living from the farm by selling cream from the Jersey herd that I had built up, from our one original house cow and a milking bale in the field, to around thirty cows and a parlour in the yard by 1975.

This turn of events had never been planned but it was a matter of survival and you never know what you can achieve with your back to the wall.

We were fortunately placed close to all the hotels at Gatwick Airport and we sold cream in gallon containers directly to the chefs at each hotel. It was hard work but financially extremely rewarding.

The children were brilliant, and both worked as hard as anybody else during their school holidays, half terms and weekends off. They even manned a stall at the bottom of the drive and sold eggs, cream, butter, and flowers!

We had a licence to sell cream and butter and a separate licence to sell milk. The lady inspectors from the Milk Marketing Board were extremely helpful and supportive so that we never minded their constant and regular inspections and tests. In fact, we welcomed them and that went for the inspectors from the Ministry of Agriculture, too.

Back to the horses. The stallion that I had purchased for cash, Carrara, unexpectedly died of a brain haemorrhage. Fortunately, I had insured him, so I was not out of pocket on his purchase price, but he died in the middle of the covering season (1973) and I had not insured him for loss of earnings. A mistake that I never repeated.

We sent the remaining mares who had come to visit him back to their homes and prepared to sit out the rest of the 1973 season with no income coming in and a stud groom, a stallion man and two junior grooms to pay.

With hindsight that was the moment that we should have cut and run but we felt that we were already in too deep to do that. We also felt, however old-fashioned it was, an obligation, certainly to the two senior members of the stud staff, as we had uprooted them and their families from their jobs in Newmarket and dropped them into this strange world in Sussex.

In 1973 we commissioned the Curragh Bloodstock Agency to buy us the best sprinter racing that year to stand as a stallion at our stud for the following 1974 season to replace Carrara.

We chose the very good sprinter Workboy, who carried the colours of Mrs Lurline Brotherton, and, having bought him, he was leased back to her for the rest of the 1973 racing season.

Sir Trevor Dawson Bt was investment chief of the merchant bank, Arbuthnot Latham. He was also a friend and we negotiated to buy the horse with a loan from the bank,

which was to be repaid by the syndication of the horse.

With the sale of 40 shares at 2,000 guineas each this would more than cover the purchase price of £20,000 for Workboy. At least, that was the theory, but we were in unchartered water, some would say hot water, and nothing at that time in the financial world was at all normal.

All the letters of enthusiasm we had received from potential purchasers came to nothing when the demand for payment of a share was made to them, and the horse was only partly syndicated.

So now we were in heaps of trouble. We could only partly repay Arbuthnot Latham, but they were brilliant. We paid them back in bits and pieces, when we could, and they never hounded us, unlike the City banks.

It was not all gloom and doom. Workboy certainly played his part and he covered twenty-four visiting mares in his first season plus two of our own mares, which was considered a success.

Our own riding horses were never stabled with the visiting mares and foals whilst the stud was a public one, so wonderful Pauline Grant, with her pet python Monty slung around her neck, kept them over at her stables and would ride them if we could not get over to visit her. The only pony allowed at the stud was a fierce little Welsh mountain chestnut stallion called Jowett Javelin, and he was used as the 'teaser' to test if the mares were 'in season'. He was a handful and Jim, our stud groom, always said he would rather deal with ten thoroughbred stallions than one wild mountain pony.

In September 1974 I started to work part time for the *British Racehorse* under the capable eye of Biddy Shennon, the daughter of Lila Shennon of greyhound fame. The magazine was edited by John Hislop, the owner of Brigadier Gerard, at that time a promising sire who had won the 2,000 Guineas in 1971.

Brandts, who, although we did not know it at the time, were by now fighting for their own survival and losing the battle to Grindlays, began to put a lot of pressure on us to sell the property and so we reluctantly sent Workboy to stand at Shadwell Stud, Newmarket for the 1975 season and, sadly, said goodbye to our loyal stud staff.

Of course, the stud did not sell. Nobody wanted to take

on a commitment of that size at that time, but then I had a brain wave. Why not sell the house and 6/7 acres around the house to a family who were looking to upsize in the country?

Brandts agreed that the idea to hive the farmhouse off from the farm was a good one and would go most of the way, if not all the way, to repaying the debt even with rolled-up interest. That would leave the rest of the farm for ourselves debt free. At least, that was the theory. Thank heavens that the property lent itself neatly to that division without compromising either of the parts that we were selling.

We sold Ham House to Mr and Mrs William Buxton and they moved in in October 1977. We sold our remaining mares and foals and finally settled our debt with the bank, who were by now calling themselves Grindlays, on 30 January 1978. We also settled our debt with Arbuthnot Latham.

We moved into the two little grooms' cottages and had as many boarding mares as we could in the by now thirty-two empty loose boxes. We kept our Jersey herd going, which by 1978 was booming, we kept our chickens and we grew four acres of potatoes which we sold in sacks round the towns and villages. We survived, in fact we expanded, buying back some of the acres from our neighbour that we had sold him three years before and gaining planning permission to build a new house.

Despite our successful survival we decided that it was now time to sell the rest of the farm without pressure and

on our terms so, in the summer and autumn of 1979, the stud farm with thirty-two acres, divided by post and rail fencing into ten paddocks, loose boxes and detailed planning permission for a single-storey residence, was advertised in the *Field* magazine and elsewhere.

The farm sold quite quickly to a man called Vic Morland, with whom I legally exchanged contracts at the beginning of 1980. In the six weeks between exchange and completion we cleared out the farm of all remaining livestock, machinery, and furniture ready for handover.

The day before completion a handwritten note, on a torn-off scrap of paper from an exercise book, was pushed under my front door at Dorset Cottage which said: 'No money, can't pay. Sorry.'

That posed an appalling problem. Technically the property now belonged to Mr Morland since he had signed the contract, but if he could not find the funds to complete the purchase then I would have to wait two years before I could, legally, take the property back into my ownership.

Understandably, I no longer wanted the farm so, in the end, I accepted a rundown letting house which Mr Morland owned in Brighton, in part payment. This property, he assured me, would continue to be a very paying investment and he managed to raise the rest of the money, in cash, by the time we completed the deal in April 1982. As with so many stories in this memoir this one also has a sequel.

The children and I inspected the house in Landsdowne Place, Brighton we had inherited from Mr Morland, and we

named it the 'whore house' since it became evident that that was largely the profession taking place there.

Tony, who had by now set up his estate agency business in Hove, kindly agreed to collect the rents, for a fee, and I resolved to get rid of the house at auction as soon as possible since it did not fit my property portfolio, which was now based and growing in London.

Before I could do this a visit from the police told me that I was in far more trouble than I thought. They suspected that I was sheltering the most wanted man in Great Britain at that time in my newly acquired house in Brighton.

Gerard Tuite (born 1955) was a senior member of the Provisional Irish Republican Army. After his escape from Brixton prison during the hunger strike in the winter of 1980 he was declared the most wanted man in Great Britain.

Following his recapture in 1982 (yes, you've guessed it, from my newly acquired letting house in Brighton, alias the 'whore house') Tuite made Irish legal history as the first citizen of the Republic of Ireland to be charged with an offence committed in another country. His prosecution in the Republic of Ireland for offences committed in the United Kingdom was a landmark in international law.*

It took a great deal of explaining to the authorities that

* Many of the IRA terrorists were released from prison in the Good Friday Agreement of 1998, which frustrated William Hucklesby, head of Scotland Yard's anti-terrorist team, who felt that much time and effort had gone into their prosecution just to be overturned by a political whim. He made his frustrations clear in a memoir he wrote before he died in March 2019, called *Memories of a Modest Man*. *The Times* Saturday, 6 April 2019.

the children and I had nothing to do with their claim that we were hiding him and, thankfully, the culprit was discovered to be one of the residents in the house.

And what happened to Vic Morland? Well, he received a two-and-a-half-year prison sentence in 1987 for a shocking but unrelated offence which was widely recorded in the newspapers and I am not sure that he ever got to move into the farm.

Looking back over those ten years it was a period of highs and many lows and we faced character-making challenges on an almost daily basis. One of the lows was my divorce from Tony in January 1978, which was so uneventful that I wondered if we had both fully understood the seriousness of the situation. One moment we were having breakfast and the next moment we were back from the courts and having lunch as if nothing had happened.

With hindsight I think that Tony might have already started feeling the effects of the dreaded neurological condition that eventually killed him, but neither of us knew that at the time. Tony was keen to open his estate agency business in Brighton and move on with his life and I was happy enough to tie up the final threads of the farm and to try to move on with my life with the children back in London.

We Pick Up Life Again in London

After we finally settled all our debts in January 1978, I was left with 3 Disbrowe Road in London, which still had a sitting tenant in it and had been considered of little value by the bank valuers.

Mrs Rubley paid next to nothing in rent and, since her husband had died, had been unable to climb the stairs to the top floor of the house which now lay abandoned and in a critical state of disrepair.

She therefore lived in one room downstairs, with a kitchen and an outside loo. She did not have a bath or a shower and had refused my offers to install either, preferring to wash herself in the kitchen sink. She was a cantankerous old girl but I kind of liked her because she had spirit.

In 1979 I found a wonderful council-owned retirement

home where I thought she might be happy, but she refused to contemplate a move there or anywhere else. Fortunately, I had more influence with Mrs Rubley's daughter who saw the benefits of the move and after weeks of negotiation we finally persuaded her mother to make the move in February 1980.

Some weeks after Mrs Rubley had settled into her new home, I went to see her. She saw me coming down the long passage towards her and shouted, by way of a greeting, 'I blame you entirely for not getting me here sooner. You made me waste so much time arguing. This place is wonderful!'

The children and I were currently renting a flat in Queensgate Place which belonged to a girl friend of mine, and we had done so since 1979 when we returned to London.

In April 1980 we extended the tenancy for a further twenty-six weeks, by which time we hoped that we might be able to move into the newly refurbished house in Disbrowe Road but of course nothing in the building world ever works out as you hope.

We extended the tenancy for a further four weeks and then another four weeks. Eventually, we moved into 3 Disbrowe Road in February 1981, a full year after Mrs Rubley left. We loved Disbrowe Road and it was our first grown-up house, after living for six years in a mobile home, so it was particularly special.

1981 was the year of the Royal Wedding of Prince Charles to Lady Diana Spencer and it was also the year that Emily, having left Downe House, her school in Berkshire, enrolled at Lady Margaret School in Parsons Green with

the intention of studying for her A level exams. It was also the year that she was launched into a busy London social life, which she much preferred and was better at, so the A level exams got shelved.

Unfortunately, it was also the year of the PCW Lloyd's crash which was not so good for me, and only goes to show that when you successfully climb out of one mire there is another mire around the corner to fall back into.

On Wednesday, 30 September 1981 Pamela Waley-Cohen, as she was then, came to work with me, in London, as my PA. She did so for several years until she remarried and from that day to this, thirty-seven years later, she has remained a close friend.

On 23 December 1981 my good friend Jen Tatham, who had helped me make Disbrowe Road such a pretty house internally, gave a drinks party. She invited me and she also invited David Wingfield, whom I had known since I was a teenager, but not that well.

We must have clicked because by June 1982 David and I had married at his home in Gloucestershire and we have remained happily married for the last thirty-eight years. He tells the story that he fell in love with me when I was eighteen, but I do not believe a word of it. In any case, I rather fancied one of his friends at the time.

After we married David wanted me, Emily and Charles to go and live with him in his house in Finborough Road on the borders of Fulham and Chelsea. It was not nearly as nice as our house in Disbrowe Road since it was situated

on one of the busiest roads out of London and overlooked a cemetery behind, but it did have plenty of space.

We sold Disbrowe Road to the engaging Elizabeth Sutherland,* who purchased the little house for one of her young relatives. The irony of the purchase was not lost on us as she was, at that time, custodian of estates which covered almost the entire county of Sutherland, and Disbrowe Road would have comfortably fitted into the smallest bedroom of Dunrobin Castle, her official home.

A few days after we had moved in with David, he received a letter from his family lawyers asking him, and his new family, to move out of the house in Finborough Road as the Trust wanted to sell it. It seems that it was not David's house after all, and the Trust no longer wanted to support him and certainly not his new family.

The news came as a bombshell to us both. Obviously, I had no idea of the original agreement between David and the Trust, and David was shocked because he clearly interpreted the agreement he thought he had with the Trust in a different way. To add to his troubles, he had made the mistake of using the Trust lawyer to represent him, as well as his brother, so there was a clear case of conflict of interests.

David was distraught because he did not have the funds to purchase the house off the Trust nor did we have anywhere else to go since I had, by then, sold my house.

* Elizabeth Sutherland, the 24th Countess of Sutherland. Born 30 March 1921. Died 10 December 2019. The title is one of the most ancient in Scotland, dating from the 12th century.

The last thing in the world I wanted to do was to buy the house in Finborough Road off the Trust, as it was in my opinion not a good property purchase. It would, also, be a nightmare to sell on, but equally I was not going to be pushed around and bullied by anybody anymore. I had just emerged from ten years of being pushed around and bullied by everybody, and now that I was married to David we had to make a stand of independence.

Resisting my natural inclination to haggle I therefore instructed my lawyers to pay the Trust lawyers the sum of money they were asking for the house, without argument, and get them off our backs. That way we could sell and move out of Finborough Road when we wanted to, in our own time and not under pressure from outside forces.

Was the Trust right to re-claim the house? Legally, it seems they were. They were not obliged to put a roof over our heads but I like to think that if the roles had been reversed we might have handled the situation with a good deal more sensitivity and would not have allowed the Trust lawyers to handle it in the way that they did.

Once Finborough Road was bought, we decided that it had to be sold and I went to see my friend, George Pope, at John D Wood, to discuss the marketing details. It was, as he predicted, a nightmare to sell largely because of the road, but two years later, in July 1984, just when we had given up all hope and dubbed George 'Pope without Hope' he appeared with a gentleman from Nigeria who seemed to love the house.

All smiles and white teeth, the gentleman drove away in his pale blue Rolls-Royce waving his be-jewelled hand and saying that we would be hearing from his lawyers … and we did! Contracts exchanged and humble pie eaten for our lack of faith in George who had, in the end, played a 'blinder'; we began to look for somewhere to live.

We found a dilapidated nursing home on Clapham Common, for which Bells, the estate agents, were asking £135,000 freehold (we paid considerably less) and we fell in love with it. The nursing home had three delightful old ladies still living there waiting to be re-housed. We wished that we could have offered them a home with us but, eventually, they found what they wanted on the south coast and went on their way.

York House, which had been an original detached farmhouse in circa 1790 when it was first built, had enormous character and some historic interest and we set about making it into a home for the four of us. We also made a two-bed flat with separate metering, which could be let if we wanted to.

We moved into our new home in December 1983 and heard the IRA car bomb explode outside Harrods on 17 December as we unpacked the furniture. This was distressing and a reminder, if any was needed, that at that time the IRA played an active role in terrorising Londoners.[*]

[*] The IRA bomb, which exploded outside Harrods, was said by William Hucklesby, the head of Scotland Yard's anti-terrorism team, to be the 'most infamous outrage' of them all even though, with six people killed, it was not the most deadly. *The Times* Saturday 6 April 2019.

We sold York House, through Farrar Stead and Glyn, to Robert Schiff in September 1985 and were totally devastated when he was drowned shortly afterwards in a tragic accident. His executors decided to re-sell the property and it went back on the market a year later in September 1986.

Back in 1981 I had written to three friends asking them if they would be prepared to open a smoked food shop with me in central London and share the costs and profit. Only one was happy to do this. His name was William Rudd and he, having recently retired from a fifty-year career in ICI, was looking for an investment and something to do.

We found a suitable shop in Thackeray Street W8. This was still trading as a butcher's shop and had been established as such over many years. The owner was retiring and the shop, with suitable modifications, was ideal for our purpose.

The shop came with all its equipment and even the assistant butcher who was prepared to stay on under new ownership. 'But we do not know anything about butchery' I protested to William. 'We damn soon will' he replied, 'with Ken to help us'.

I was very doubtful, especially as William, the bit now firmly between his teeth, intended to add 'wet fish' to the list of 'goodies' to sell in the shop. If we did not know anything about butchery, then I was equally sure that we knew diddly-squat about fishmongering, even with my limited wet fish experience at Devon Smoked Foods Ltd. This had not been my idea at all, but William was right inasmuch as

we would never have made enough from the delicatessen counter alone to cover the overheads.

Since William had far more money than I did I was very happy to agree to a minority partnership. In any case, having sown the seed of a venture, it would be great fun to see it through together. And it was. I do not think that we stopped laughing for weeks.

The shop, which we called Rudds, opened on Monday, 12 July 1982 and there is a picture of the three of us, William, me and Ken, in our white overalls ready for business.

Gradually, I found that I was doing far more property than selling in the shop and both the delicatessen counter and I phased out. By this time William was running the wet fish counter and Ken was running the butchery department and I left them to it.

William kept Rudds going for a long time, or until he went with his wife, Anne, to live in Majorca and Nicholas Soames, who lived in a flat opposite the shop, kept Rudds going with his large orders for meat.

In February 1983 Sir Trevor Dawson Bt was found dead by his chauffeur at his home in Eaton Square. He was involved, through Halliday Simpson & Co (Manchester), with one of the biggest scandals ever to hit the Stock Exchange. All of this was very upsetting. Trevor had been a friend of ours and the Dawson family were pillars of the City of London and the social establishment.

Why does this bit of information matter and does it have any relevance to my story? Well, yes it does because, if you remember in an earlier chapter, it was through Trevor Dawson that Tony and I obtained the loan to purchase the racehorse, Workboy, to stand as a stallion at our stud. Trevor was a great racing man and the loan to purchase the horse was put through the merchant bank, Arbuthnot Latham, where Trevor was investment chief.

Dawson and his deputy, Michael Barrett, were suspended from their posts at Arbuthnot Latham in July 1981 when the Halliday Simpson case erupted, and a Stock Exchange inquiry followed.

Trevor's father, Hugh, had been a close friend of Tony Harrison, my husband at the time, and they had both served together on the committee of the Shipwrecked Mariners' Society for many years. Thank goodness we had paid back all our debts, including our debt to Arbuthnot Latham, by 1978, before the Halliday Simpson scandal broke in the newspapers in January 1982.

David's Family

I was very lucky with my mother-in-law, David's mother. She became a good friend of mine. It cannot have been easy for her when her son announced in April 1982, whilst they were doing church flowers together, that he was going to marry, at the age of forty-nine. 'Anybody I know?' she asked. 'No,' said David and offered no other explanation. Fortunately, her beloved brother, David's Uncle Jack, had met me and must have reassured her to some extent because she took me at face value and we never looked back.

I did not meet David's father, who had died in January 1952, but until that time all the Wingfields lived at Barrington Park, a Grade 1 listed house in Gloucestershire. Thereafter, it became the home of David's brother Charles and his family, and my mother-in-law moved to a house in Fairford, about twelve miles from Barrington, her home until her death in 1990.

Over the years Barrington Park had fallen into major disrepair but it was still not ready for the waspish pen of James Lees-Milne, a heroic saviour of historic houses, who published the twelfth and final volume of his diaries* in 2005.

The miracle is that Barrington managed to escape the attention of Lees-Milne in any of the previous eleven volumes of his diaries, but his biographer, Michael Bloch,† explains this omission as follows: 'In 1996 he [Lees-Milne] was "fascinated" to visit Barrington Court [Park], Gloucestershire, seat of the reclusive Wingfield family, to which he had been trying to gain access for sixty years.'

The occasion reminded Lees-Milne 'of my wartime visits to remote country houses and harassed owners' and he wrote a diary entry worthy of that time. He had this to say in summary. 'In all my days of country house visiting I do not remember a more tragic case than Barrington.'

Charles Wingfield was unable to complete his mission to restore the house because he died in 2007 so it fell to his son, Richard, to undertake the task ... and what a task it was. Because I had been in the building trade for so long Richard was generous in inviting both David and me, as well as other members of his family, to see the progress of the refurbishment as it unfolded.

The herculean project took over four years to complete

* *The Milk of Paradise Diaries* by James Lees-Milne. Pub. John Murray 2005, pages 230–231.

† *James Lees-Milne: A Life,* by Michael Bloch. Pub. John Murray 2009, page 350.

and I like to think that James Lees-Milne would have approved of the final result. He would certainly have been surprised that the Victorian wings were kept since he predicted that they would have to be sacrificed to retain the original George II villa, built by William Kent, in 1735.

My sister-in-law, Meriel, of whom I was very fond, was one of the few people to mourn the demise of the house as it had been. 'I can't get my head around the new house,' she said. 'I preferred the old house, leaks and all. I think it must be the Irish in me!'

I suspect that my mother-in-law and her brother, Jack, might have agreed with her sentiments. Neither of them would have embraced the 21st century happily and I remember the shock horror registered by Uncle Jack when David and I drove him around Poundbury,* which we thought was immensely exciting and he thought was awful.

* The show town conceived by the Prince of Wales and built on Duchy land in Dorchester, Dorset.

Cheselbourne Manor

Cheselbourne Manor was the home of David's Uncle Jack from 1948 until he died in 1999 at the age of ninety-five. Fifty years is a long period and during that time very little was done to the house.

Lieutenant-Colonel J. R. E. 'Tishy' Benson DSO was David's Uncle Jack. To David and me he was a good friend with a great sense of humour. He ruled his household along military lines and with no concession to 20th-century scientific advance. It was only at the end of his life that he was persuaded, reluctantly, to install a washing-up machine when the endless trudge between pantry and kitchen became too much for his housekeeper, who was already in her eighties.

For some extraordinary reason the Uncle would never have hot water put into the kitchen and he fought to the end to resist the suggestion. The kitchen had an old butler's

sink with a cold-water tap. Every pan, therefore, had to be carried through to the pantry where the hot tap ran in a dribble because it was so furred up.

One of the areas which could truly be said to have been 'in an original state' (an expression so beloved of estate agents), was the linen cupboard. There, the word 'linen' took on a whole new meaning.

The cupboard itself was a wildlife delight. A haven for flora and fauna. The state of the linen is best summed up by Sheila Swanson, the Uncle's housekeeper at the time. I remember Sheila telling me that she spent a lot of her time 'cobbling up old rags' and it was true.

In the end, there was no material strong enough around the holes to hold the thread anymore. The Uncle had a pathological aversion to purchasing anything new for the house and an even greater aversion to anything being thrown away, so the rags stayed.

The curtains throughout the house were in a similar condition and great care had to be taken in drawing them if you were not to be left with an embarrassing handful of rotten material.

Eventually, the dining room curtains, which hung in festoons and had to be carefully arranged across the window when they were closed, were relegated to the bonfire by us and new ones hung before the old boy came down for breakfast.

We waited for the storm of disapproval to break over our heads, but nothing happened. We finished our cornflakes,

or perhaps it was Weetabix, and were just congratulating ourselves that he hadn't noticed when he said, 'I've always thought that green went well in a dining room,' and that was that.

Ghosts: they were certainly there at Cheselbourne although neither David nor I ever saw one. The Uncle did, however, and it made a big impression on him. Likewise, the gardener. My brother-in-law, Jonathan, said he had a nasty experience with one in bed when the ghost tried to pull the bedclothes off him but I am not sure that we believed him.

The house was not as old as Uncle Jack believed. He thought that it dated from 980 AD, but it was certainly old enough to have ghosts – and historic ghosts at that.

On the face of it the Uncle was the least likely individual to see something as intangible as a ghost, being a highly disciplined military bachelor with a distinct lack of imagination – or so we thought.

He would never indulge a fantasy but it is a fact that most nights, after the household had gone to bed, he would tiptoe on to the landing – the floorboards gave him away – and peer through the window hoping to see, just once more, the ghost and his lantern.

The more cynical of his friends suggested that the excellent port he sometimes indulged in after dinner may have had something to do with his vision, but the Uncle would have none of it. He had seen a ghost and the rest of us knew better than to question it.

When the house was left to David by the Uncle in 1999,

the interior was in a dilapidated state. Almost all the plaster was 'alive'. At best it pre-dated the last War and much of it pre-dated the First World War. The specification alone for this work made our financial advisors nervous, and that was before we had received estimates for the plumbing and the provision of bathrooms and a kitchen.

A hotchpotch of nine different metals made up the plumbing system. All the pipes noisily and inconveniently ran through the main rooms, to the despair of any interior decorator. All would have to be removed, formalised, and put back invisibly.

Reluctantly, after professional advice, much heart and bank search, we decided to market the property and the rest, as they say, is history. Well, not quite.

The Times, on 21 March 2001, featured a two-column report on a trial for the attempted murder of a man by his wife. This might not have caught our eye but for the fact that the report carried a large photograph of the couple's house, which had been our house before we sold it to them in 1999.

Through this transaction we had come to know the purchasers reasonably well, which adds to the interest of the story but in another way complicates it as our emotions are involved.

From our personal point of view, we are not very happy that poor Cheselbourne is dragged through the mud and 'named and shamed' in the press.

The photographer, who had clearly not been invited in for

tea by the new owners, had taken his photo from the only angle he could get without trespassing. Namely, from the public lane some distance behind the house, using a long lens.

From the new owners' point of view, and their friends, it is a sad and sorry saga but, from the public point of view, this is a story with an interesting twist, for many victims of violent crime do not live to tell the tale. The husband's graphic details of his waking up to find a plastic bag over his head and fighting against time to get it off makes any novel by Agatha Christie read like a child's bedtime story.

Later, when he found enough strength to tear it off, he discovered that the strong little hands that held the bag so tightly round his mouth were those of his beloved wife.

The wife, who claimed that she loved him dearly, begged him to forgive and forget but, whilst he assured her that he had forgiven her, he was having some trouble with the forgetting bit and doubted that he could do what she wished. Particularly as she is alleged to have drugged his breakfast Weetabix first, which implies some degree of premeditation.

We had not overestimated the cost of bringing Cheselbourne back into the 21st century. It was a hefty figure and certainly too deep for our pockets, but it was sad to read in the newspapers that the new owners had discovered this too, to their cost.

The couple were already having problems in their marriage, which grew amid the wife's attempts to renovate their new property. Her husband said (as reported by *The Times*)

that they initially thought that this (the renovation) would cost £100,000. 'But by the spring of 2000 we were over £200,000 and maybe £250,000 and I was not pleased at all. It caused some frictions,' he said.

Perhaps we should feel relieved that we made the decision to sell the property. After all, our total estimate for the Cheselbourne renovation was well in excess of the sum that the new owners had already spent, but there are times when making the right decision brings no satisfaction at all and I am sad that their troubles had been exacerbated by the stress of the Cheselbourne refurbishment.

Back to the trial. After eight days it finished, and the wife was acquitted of attempted murder, against all the odds. The husband is said to be 'stunned', as indeed are the rest of us. The Winchester Crown Court jury of seven men and five women took just fifty-one minutes to decide that the wife was suffering from depression at the time and did not mean any real harm to come to her husband. She just wanted to frighten him into taking some action to save their marriage of two years.

Despite the positive outcome of the trial for her, the marriage was not saved, which may come as no surprise to many of you.

Jim Bailward &
the Uncle

On Saturday 15 July 2006 we attended a service of thanksgiving for the life of James Bailward, the husband of Uncle Jack's favourite niece, Di. As the tributes poured in I was reminded of my own memories of Jim fishing with us at Soval, in the Isle of Lewis, and eating six eggs for breakfast, not to mention the black pudding.

Jim Bailward had been a Japanese Prisoner of War for three and a quarter years. When the Japanese government eventually paid out compensation to their prisoners in 2002, Jim decided that his fate had been no worse than anybody else who had fought or been imprisoned elsewhere during the War. He did not think it right to be paid for it. He therefore donated his £10,000 compensation to the

British Legion who opened a memorial garden in his name at Bishops Lydeard.

My favourite recollection of Jim took place toward the end of Uncle Jack's life. The Bailwards had come from Radipole, where they lived, for dinner. After dinner we went to sit around the fire in the monk's room. The Uncle, who was over ninety by then, had a tendency to pass out, presumably as the result of the blood not getting up to his head. At any rate, as he got out of his chair this happened and he went down in front of the fire. Jim looked at me, Di and David, decided that we were all puny little pip-squeaks and with a deep sigh slowly got to his feet and lifted the Uncle up as if he were no more than a rag doll. His little legs and arms hung limply as the giant suspended him in space before lowering him gently into his chair. Jim then went back to his own chair, whereupon the Uncle came to and with no break in his own mind continued with the conversation that he had started before the incident.

Mrs Bluett was the housekeeper at Cheselbourne. She was frail and almost as old as the Uncle. According to him she had lied about her age when he interviewed her and conned her way into his employment. She could not possibly lift him up after his increasingly frequent bouts of fainting. She would step over his prostrate body on the floor and dial 999 for an ambulance. In due course the ambulance would arrive, remove the Uncle to the local hospital whereupon he would discharge himself and come back to Cheselbourne Manor in a taxi.

Corinthian Construction

I started Corinthian Construction Consultants Ltd around 1979, partly in an attempt to replicate our earlier success with LHS Ltd and partly to pay for the children's school fees.

I put a large advertisement in the *Yellow Pages*, at the time the local London directory for all tradesmen, and I also went to the City for direct contacts.

One of my first calls at 11am on Wednesday 18 February 1981 was to see my cousin, George Corbett, who was at that time head of commercial property at Vigors. George, who took gravitas to extremes, greeted me very formally and I pitched my idea to him.

In typical George style he showed no reaction to my enthusiasm, but he did say that if I found an opportunity to

use the talents of his son, Adrian, on any decorating jobs he would be grateful. My cousin Adrian was at that time living at home and doing, according to his father, not very much.

George then dismissed me, as only George could, with a flick of the hand, and I found myself outside his office door with no promise of contacts, jobs or much else.

Some weeks later I got a call from a commercial agent who wanted Corinthian to do a very speedy job to reinstate a factory at Heathrow to comply with an end-of-tenancy agreement. The money seemed to be very good. It was, the agent said, largely a redecoration job and it was to be completed in two weeks for handover.

I rang Adrian – was he free to meet me at the factory to assess the work? I arrived at the site first, so to some degree had already absorbed much of the shock before he arrived in the car, with his mum at the wheel. The factory was massive from the outside, but nothing to the awesome space inside. We stood in silence. The sheer volume overwhelmed us.

There was Adrian, there was me, and there was (in theory) the pot of paint. Eventually Adrian said 'Mary Ann, if the three of us painted this space for ten months we wouldn't finish it, let alone in the two-week time frame that they have given us.' 'Do not count me in to the three of us,' said Pippa his mother, 'I am having nothing to do with it!'

In silence the agent handed me the schedule of dilapidations, all of which were to be carried out, as well as the painting, within the same time-frame. 'Do you think that George is behind this outrageous request?' I asked Adrian.

'Quite possibly,' he replied. 'It would appeal to his sense of humour.'

Back at base I wondered what to do next. If George were behind this, I was not going to let him have the last laugh. What contractor did I know big enough to sort this dilapidations fiasco out in two weeks? Not only a large enough contractor but one who was prepared to drop everything to do the work. I was determined not to refuse the job because that was clearly what I was expected to do.

In desperation I turned to my sixteen-year-old son, 'What shall I do?' I wailed. 'No problem' he said, 'my school mate Kevin's dad would do that job standing on his head.' And so it was – Kevin's dad did do the job and did it within the time-frame as well.

I met Kevin's dad at the site several times. He was a wonderful mentor to me then and later on in my property career after he built up a really successful contracting business in Sussex. His Rolls-Royce would glide up, he would hop out and nothing was ever too big a challenge. He had the most amazing 'can do' attitude and when he died, sadly too young, he left a big gap in all our lives.

Sometime after the factory saga had completed, Kevin's dad confided that he had had to pull out all the stops to do that job, employing more than twenty-five men to get it done in the time and working all hours, but it presented a challenge both to me and to him so we got it done. I can't say that in the end either of our careers was the worse for it.

The Wingfield
Sporting Gallery

In 1986 I opened a new shop,* giving support to the French claim that we Britons are a nation of shopkeepers. Actually, the French never said anything of the sort because it was the Englishman, Adam Smith, in his book *The Wealth of Nations*, written in 1776, who said that Britain 'was a nation that is governed by shopkeepers'. For some reason the French picked up on this with, I suspect, great glee and it has been wrongly attributed to them ever since.

The four-storey freehold building at 55 Old Town Clapham was in a pretty derelict state when I bought it in November 1985 and I do not really think that I had thought through what I was going to do with it when I had finished the refurbishment, other than sell it on in keeping

* In 1982, I had opened Rudds with William Rudd, in Kensington, London.

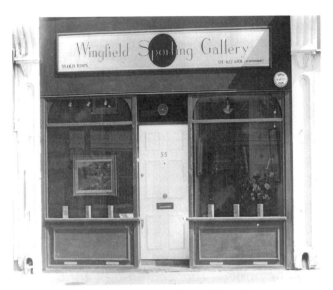

with our normal company policy. The Pavement was not the smart shopping experience that it is now, but we were pioneers in an improving area.

Gradually, we came to the conclusion that we might be able to house the many paintings and books that I had collected over the years in the basement and open the ground floor as an art gallery for sporting art.

The gallery, which we originally called the Sporting Gallery, opened on 24 February 1987 and was immediately closed as we were, unknowingly, in breach of copyright and another 'Sporting Gallery' threatened to sue us unless we changed our name and all our promotional literature.

The Sporting Gallery, as far as we could ascertain, had not been active for some time but they did still hold the rights to the name and our lawyers advised that we should take no chances.

The now newly named Wingfield Sporting Art Gallery

opened on 28 April 1987 with an exhibition of Football Art, which was presented not by us but by Harry Langton, the great collector of football ephemera. He borrowed our gallery to show his wonderful collection, which gave us the time to have all our brochures and stationery reprinted with the new name, at considerable cost to, but in the end benefit of, ourselves.

Fortunately, I had already given my first solo sporting art exhibition at the Mall Galleries, London SW1 in June 1985, which had been a surprising success, so I was not a complete beginner. The exhibition, entitled 'Play the Game', covered several popular sports including rowing, motor racing, cricket, tennis, and golf.

"Play the Game"

Mary Ann Wingfield

Requests the Pleasure of your Company

At her Exhibition of Sporting Paintings

to be opened by

The Rt. Hon. The Earl of Gowrie

Chancellor of the Duchy of Lancaster

and Minister for the Arts at

The Mall Galleries, The Mall London S.W.1

On Monday June 24th 1985 at 11.45 a.m

The Exhibition will continue until Saturday 29th June, 4.30p.m

R.S.V.P.
35 Southside Clapham Common
London S.W.4. 01 622 6301

Champagne
Please bring this Invitation

Our success may have been due, in part, to the help of Tom Coates* who taught us how to hang pictures professionally and to the exhibition opening speech by Grey Gowrie,† who was at that time Minister of Arts in Margaret Thatcher's government.

When I first started collecting sporting art back in the late 1960s I was irritated that there was very little information written on the subject, so I resolved to write my own reference book and then, in 1984, I looked around for a publisher.

I approached six or seven publishers who appeared to cover associate subjects, but nobody seemed to be quite right and, more importantly, nobody seemed to be interested in my book. All the publishers refused my request to publish my work including the Antique Collectors Club (ACC), who was my number one 'go to' publisher.

It was several months after my original application that John Steel of the Antique Collectors Club wrote back to say that he had given further thought to my ideas and he had a few of his own to contribute. Would I meet him in his London 'office' (which happened to be the Fountain Room at Fortnum & Mason) on Tuesday, 15 October 1985 and perhaps we could knock a few ideas about over coffee?

From this initial meeting he and I hammered out the bones of not one book on the history of sporting art, as originally planned but, because the subject was so big, a series of three or four highly illustrated hardback books

* Thomas J. Coates, b. 1941. PPNEAC Hon PS, Hon RBA, RP, RWA, RWS.
† 2nd Earl of Gowrie. Born 1939. PC FRSL. English politician.

which he felt had some commercial value, particularly in the USA which was an important market to the ACC Ltd and, I suspect, most publishers.

I went back to the drawing board to rewrite the first book in the series, which ACC commissioned, along the lines John Steel had suggested. This book was called *Sport and the Artist. Volume 1: Ball Games*, a sumptous hardback, with a foreword by Morys Aberdare,* which was published by the ACC Ltd in 1988 and successfully sold out at £29.95.

SPORT AS ART

A work of reference and a pleasure to look at, Mary Ann Wingfield's book *(Sport and the Artist, Vol 1; Ball Games,* Antique Collector's Club, £29.95) covers a wider field of enquiry than might be anticipated. Each game is accorded a brief account of its rules, sporting and social history. The somewhat indiscriminate choice of illustrations only adds to the pleasure. Thus Van Gogh and Beryl Cook lie between the same covers, which must be a sporting record of some kind. This is Vol 1. Vol 2, Country Pursuits, and Vol 3, Contests, follow.
FH

BATH CONNECTIONS. DEC. 1988.

John and I were already working on the second book in the series, *Sport and the Artist. Volume 2: Hunting*, when he announced that he and his publisher wife, Diana, would be going their separate ways and that she would be taking over the Antique Collectors Club. This happened officially in 1991 but in practice had already been in place earlier.

* Morys Bruce, the 4th Lord Aberdare (1919–2005) PC (1974) KBE (1984). President of the Tennis and Racquets Association (1972–2004). Morys Aberdare was one of the outstanding real tennis players of his generation, winning the singles amateur championship four times during the 1950s and 1960s and winning (four times) the amateur doubles championship. He wrote *The Story of Tennis* in 1959 and the Willis Faber *Book of Tennis and Racquets* in 1980.

This was definitely not good news for me. It had been apparent for some time that there were two camps in this publishing house, and I now found myself in the wrong one. Furthermore, Diana did not like sports of any kind, preferring gardening, antiques and pets.

After John left ACC nothing would induce Diana to publish the second volume of *Sport and the Artist*, which was devoted to what she called 'blood sports', even though I argued that the sports and the paintings were largely historic.

She was persuaded to publish an illustrated address book, using some of the material I had archived on horse racing, in 1991 and to her eternal credit she published *A Dictionary of Sporting Artists (1650–1990)* in 1992. She never really believed in the sporting art theme, though, and refused my plea to allow the dictionary to be illustrated. Later, and with the benefit of hindsight, she believed that this had been a mistake.

I was immensely fortunate to acquire a very good team at 55 Old Town to help with my books and to man the Gallery. Georgie Heywood joined me in September 1986 and Karen Young joined us on 24 February 1987. We worked well together as a team and I was very fond of them both.

The very first exhibition we launched at 55 Old Town seems to have been well received and the press reviews were very supportive.

From this point onwards the Gallery flourished, and the press reviews continued because we always had something

of interest, which was different from anybody else, and that is what the art press needs to feed on. We also had easy-to-read press releases, ready to hand out instantly, which made the work of the reporter much easier.

As well as our own 'in house' exhibitions we were invited to exhibit at external venues as well, so that we picked up new clients on a pretty regular basis.

With the publication of *Sport and the Artist: Vol. 1*, the *Dictionary of Sporting Artists* and the little racing book that ACC published in 1991, alongside the Sporting Gallery itself, our profile was riding high, or so we thought, and I was invited to write articles, attend exhibitions, speak at seminars, give addresses to the great and the good and generally do our bit for charity.

THE Wingfield Sporting Gallery

55 Old Town, Clapham, London SW4 0JQ, Tel: 01- 622 6301

We celebrate our first anniversary in March and we have come a long way in a year. We have also learnt a great deal about your own tastes and preferences, and are keen to continue our search to satisfy these on your behalf.

Thank you for your support, which we hope you will continue to give us. We will assume that you would like to be kept in touch twice a year with our news and forthcoming exhibitions, unless we hear to the contrary.

October 15th 1988 is the publishing date of Sport and the Artist, by the Gallery Owner, Mary Ann Wingfield. This first book in a series of three, is devoted to the history of ballgames and is fully illustrated with paintings of the different games throughout the years.

In November, our first National Sporting Painting Competition is to be held, in conjunction with a major sponsor. The best sports paintings of sports events will be chosen, in which a different sport will be represented each year. The competition, which we hope will become an annual event, is an exciting challenge to artists nationwide to compete for major prizes in this under-developed field.

Please contact us for details.

35 Sibella Road, London SW4 6JA, Telephone & Fax: 071-622 6301

14th July 1992

OLYMPIC ART EXHIBITION TO OPEN AT ST. JAMES'S

The Imry Group and PosTel today announced that they are to sponsor a major public exhibition of Olympic Art at Ryder Court, Ryder Street, St. James's from 31st July to 14th August 1992.

The exhibition will be presented by Wingfield Sporting Art, and 10% of the sale proceeds will be given to the British Paralympic Association, which is sending 200 athletes to represent Great Britain in the 1992 Paralympic Games in Barcelona.

Wingfield Sporting Art has assembled a collection of paintings with a sports theme from some of the nation's leading artists, including Kevin Whitney, Angela Newberry, Sarah Coghill, Zil Hoque, Laurence Broderick and Fletcher Sibthorp. A total of 60 works, ranging in price from £100 to £10,000 will be on display.

The exhibition is being sponsored by property developer The Imry Group of Companies and PosTel Investment Management Limited. Imry have made available the ground floor of their 56,000 sq. ft. office development at Ryder Court, 14 Ryder Street, St. James's for the exhibition as it is an ideal location to present such an important and topical exhibition. In particular, the space is in striking contrast to the surrounding old master galleries of Duke Street.

Ryder Court has been rebuilt behind a retained period facade to a most exacting specification. 44,200 sq. ft. of space remains available at rents from £25 a sq. ft.

Enquiries:	Mary Ann Wingfield	Iain Taylor
	Wingfield Sporting Art	Hudson Sandler Ltd.
Telephone:	071 622 6301	071 796 4133

The Kray
Brothers

Our profile took a distinctly quirky turn when we received by far the weirdest commission we ever had from a mystery caller in 1990, who said that he represented a very famous person who wanted one of our artists to paint his portrait but he could not tell us who the famous person was. This caller made an appointment to come and see us on the following Monday, at teatime, when he said that he would reveal the name of his client.

By 1990 we had sold 55 Old Town Clapham and were re-sited at 35 Sibella Road SW4, from which address we had launched a series of signed, limited edition sporting prints which we sold to retail outlets all over the country.

Monday duly came and David, me, Charlie (who was by then working with us) and Lois Glass (our new secretary)

assembled in the drawing room at Sibella Road with the tea things. Could this mysterious client be Prince Charles, we speculated: he was very keen on art?

At the appointed hour, a large black car drew up outside the house. The car windows were heavily tinted. A man got out from the back of the car, dressed in black, with a flower in his buttonhole and wearing shades. Our hearts sank. Even with the shades it was unlikely to be Prince Charles. 'I am Nick,' he said, and we attempted to shake his hand.

With only two fingers on his right hand, shaking hands was quite difficult but Nick showed no unease. We counted three fingers on Nick's other hand, which made us wonder how he had lost them. We did not have long to wait. 'I work for the Kray brothers,' he said.

'Really?' I found myself saying in a voice that was at least an octave higher than it should have been. 'How interesting.' 'Yes,' said Nick, 'it is.' 'But I thought they were both in prison for life?' I said. Charles instinctively moved the plate of chocolate biscuits out of Nick's reach.

'They are,' said 'No Fingers' Nick, deftly whisking one biscuit off the plate before it disappeared, 'but they operate many businesses and they have a large office outside the prison which I run.'

This was undoubtedly the notorious Krayleigh Enterprises, a lucrative protection and bodyguard business, which the prison authorities had discovered, rather late in the day, that the Krays were running. They longed to close it down but could not find enough reason to do so.

It seems that Ronnie Kray wanted to get married again (he had only just divorced his first wife, Elaine, the previous year, 1989) and this painting was to celebrate his wedding to Kate Howard, a kissogram girl, which was to take place, in the prison chapel, in 1990.

The artist whom he wanted to use worked closely with us and had done a series of signed boxing prints of Barry McGuigan with which we had had a great success, especially in the north of England where the prints sold in the pubs and back street shops for cash.

'Reggie is a bit of a painter himself,' volunteered Nick. It was true. In addition to murder, extortion and extreme violence, both twins had a lifetime passion for boxing and had been in their youth, particularly Reggie, very good at it. Reggie Kray had taken up painting in his later years and although he was not particularly good at it, boxing scenes were a favourite subject.

We promised Nick that we would contact the artist that Ronnie wanted. We would not take an introduction fee if the artist decided to take up the challenge (unlikely, we felt) and any negotiation was to be strictly between Nick and the painter and not involve us.

'Whew,' we said once we had waved Nick goodbye. The artist will not be interested in the commission and that will be the end of that. But of course, it wasn't. The artist, it seemed, was extremely interested in the commission, particularly since it involved being smuggled into Broadmoor prison which he thought would be a great adventure.

'Our involvement ends here,' I announced firmly. And it almost did except that a few weeks later I was weeding the front garden when a large black limousine slid into view and came to a halt in front of me. The driver's window wound down and the driver, dressed in black, shot an arm out through the window in which he grasped a beautiful bouquet of flowers. 'These are for you,' he said, 'my guv'nor says thanks.'

Eventually, David and I got tired of getting up at 4am on a Monday morning to flog prints to the north of England and return home on a Friday evening. We definitely made money but we felt that this was not where our expertise lay, nor was it how we wanted to spend our lives, pounding up and down the motorways and spending Monday to Friday in B&Bs in Halifax, Hull and Hexham.

In 1993 we wound down the business, put Sibella Road on the market and looked around for other property projects in London.

A Tale of Two Priests

At the end of 1990 my daughter, Emily, introduced us to Adrian Lee, the man she said she wanted to marry. He was tall, slim and extremely good-looking but we were somewhat amazed, having no inkling she even knew an 'Adrian Lee...'

'Who is he and what does he do?' we asked.

'Oh, he is a trainer in Newmarket with his own yard,' she replied.

My knowledge of trainers in Newmarket, gleaned from my ten years' experience as a thoroughbred racehorse breeder in Sussex, swung between the very respectable and the downright dodgy so I received small comfort.

'His parents live in Wales. Oh, and I think that you might have known them at school,' she said, in a throw-away line. David and I were totally bemused. We did not

know anybody called Lee who lived in Wales and the whole situation was fast getting out of hand.

The following Monday morning David and I had to leave at 4am to sell our prints in the North of England and, as usual, did not return to Sibella Road until late on Friday evening so all further conversation on the Lee subject was put on hold.

The children, meanwhile, had other ideas. 'We have become engaged,' they said, on our return, 'and we are going to announce it officially in March after you have met Adrian's parents.'

'Oh,' I said, 'sweet of you to think of us. What happened to good, old-fashioned asking permission to marry?'

'Old hat,' they replied, 'but Adrian will ring you this evening from Newmarket.' And Adrian did. 'I've looked at Emily from all angles and aspects,' he said, 'and she is absolutely perfect.'

'Have you felt her fetlocks?' I asked.

'Sound as a bell,' he replied, failing, apparently, to see the irony.

We met Chris and Belle Lee for lunch in Newmarket where they were staying with Adrian. We totally fell in love with them and it is a friendship that remains as strong today as it was when it was first formed in 1991, but of course the association goes back far further to our school years, when I was at Sydenham House with Shirley (Belle) Atkinson and Chris Lee was at Bradfield with David Wingfield.

The vexing question about where Emily and Adrian should

get married came to a shudder when Emily decided that she did not want to get married at St James's, Piccadilly, where she had been christened, but she did want to get married in London.

In 1992 there were very few women priests but there was one at St James's, Piccadilly, albeit that she was Danish. She was charming and I liked her but Emily, mindful of the Church of England's ruling at the time, felt it was too soon to go against convention, so we looked for somewhere else.

David consulted Eric Evans,* who had known David's mother for many years and who had given the very moving address at her memorial service in April 1991.

Famous for his affinity with the young, Evans insisted on meeting Emily and Adrian several times, privately, then invited them to see the Chapel of the Order of the British Empire in the Crypt at St Paul's Cathedral, to see if that might suit their wedding plans. It can hold 250 seated guests. It helped that Chris Lee was a CBE and Eric Evans was, at that time, Dean of St Paul's.

Eric, a firm supporter of the Royal Family, was a traditionalist and did not support the Church of England's decision to ordain women priests. He became known, in the same year that Emily and Adrian married, for charging tourists after he discovered a deficit of about £600,000 in the cathedral budget. Unlike continental cathedrals, English cathedrals are not maintained by the state.

* The Very Rev. Eric Evans KCVO. Born 1928. Died 1996. Dean of St Paul's Cathedral from 1988 until his death in 1996.

The wedding date was set for Thursday, 16 July 1992 which was a very hot day, so the Crypt at St Paul's Cathedral was probably one of the coolest places to be in London. Eric insisted on taking the service himself but by 1992 he was wracked with arthritis (not helped by his passion for chocolate) and his progress was very slow and painful.

In September 1994 Eric was on holiday in Wales but he kindly came to christen George (born 30 May 1994), Emily and Adrian's son at Llangenny Church, which was the Lees' local church near Crickhowell.

Eric loved children and the service was going well until the colourful (lady) resident vicar, who had been away on holiday, suddenly appeared, seized the baby from Eric and said, 'You can go now, I am back.'

If Eric's misgivings about the ordination of women priests were uppermost in his mind at that moment, then his natural diplomacy came to the rescue, but it was an interesting split second.

Sadly, by the time that Zara (born 20 November 1995), Emily and Adrian's second child, was ready to be christened in June 1996, Eric was ill. When he died, two months later, at the age of sixty-eight, we all felt that we had lost an irreplaceable friend.

It was several years later that my son, Charles, got married. He was thirty-seven, and up to that time we had not known that he had a special girlfriend. We were in the car one day. The two Lee children were in the back seat, having spent the afternoon with their Uncle Charlie, and we had

just picked them up from his house, in Mere, to take them home.

Emily and I were saying how sad it was that Charles did not have a girlfriend to share his house when suddenly a voice from the back seat said 'I think that you will find that he does have a girlfriend and he is about to get married.'

'Whaaat!' we cried, 'how do you know?'

It seems that Charlie, fondly thinking that both children were playing quietly at one end of the room, had not seen George climbing under the table at which Charlie was sitting telephoning.

George, aged seven, had heard everything and the reason that we knew nothing about Charlie's girlfriend (we were informed by George) was because she lived in the USA and had never been to England. We tackled Charlie. 'Yes, it is true,' he said, 'her name is Laura Marino. She is an American citizen, but her family are Italian.'

Charles and Laura's wedding took place on 23 June 2001 and it could not have been more different from Emily and Adrian's wedding if we had invented it. The marriage ceremony and the reception took place at the Yacht Club, on the seashore, close to where the Marinos live in Stamford, Connecticut, USA.

Neither Charles nor Laura felt committed to a religious service, but Laura's mother is a staunch Roman Catholic so, as a concession to her religion, Charles found 'Rent a Rev' on the internet and booked him. A Roman Catholic priest, with liberal ideas, he was instructed to put together a

one-off marriage ceremony, tailor-made for them, but with a nod to the Roman Catholic faith.

Eric Evans may have been a traditionalist, but this priest was in a different league altogether and 'liberal' took on a whole new meaning in his hands. For a start he was a married Jesuit, a contradiction in terms if ever there was one, living north of New York, and his capacity for red wine at the dinner David and I hosted the night before the wedding seemed limitless.

He was the life and soul of the party that evening and, as he clutched a pillar for support with his black cassock billowing out behind him, Chris Lee was heard to murmur 'Oops, there goes another picture for *Tatler*.' 'Rent a Rev' was nobody's idea of a conventional priest but then Charlie and Laura had not wanted that.

The next day, if 'Rent a Rev' was hungover then there was no sign of it. He turned up on time and, as planned, conducted a superb wedding service in the Yacht Club garden, at the edge of the water. He led us through the marriage ceremony, and it was a totally spiritual experience. Everybody was moved and touched in some way by this priest with his unconventional ideas and methods.

After the event he disappeared and, twenty years later, nobody has ever heard from him again. Easy come, easy go, which is a modern concept, I suppose, but somewhat at odds with the British tradition of a priest being a family friend for life.

The Old Nunnery

In 1993 I visited my good friend Nick Goble at Winkworth estate agency in Battersea. I was looking for a large house to do up in the area but nothing he showed me fitted the bill.

At last, in exasperation, I said: 'Well, I've seen the best properties that you have on your books, now please show me the worst.' Nick thought for a bit and then said, 'I do have an ex-convent, which we have had registered for some time but are no longer actively marketing.

'You would have to apply for a change of use from institutional back to residential, but it is large and the only other building that I can think of that might suit.' We went to see the convent at 191 Battersea Bridge Road SW11, and Nick was right, it was a gaunt institution with as much charm as a prison.

Matters were not improved by the fact that it had not

been lived in for some time, the resident nuns having long since decamped to their main base in Westminster. The whole place was cold, damp and extremely depressing.

'You see,' Nick said, 'I told you that you would hate it.'

'I *do* hate it,' I said, 'I hate it enough to buy it and transform it.' Strange woman, thought Nick, although he was polite enough not to say so out loud.

The Salesian Sisters of St John Bosco, or Daughters of Mary Help of Christians (founded in 1872), was the order of nuns that had vacated the convent I now sought to acquire. A teaching and educational body, the nuns must have been well-regarded within the community because, for a long time after they had left, we found gifts of food and socks outside the front door.

Eventually we were forced to leave notes for the unknown donors saying, 'No more food, please.' The socks were interesting since they were an enormous size and clearly meant for a man with large feet. For which nun, we wondered, could they have been intended?

My son wore a pair while travelling the world on his gap year, and they survived the challenging conditions to which they were exposed surprisingly well. Eventually, on their return, and whilst my son and I were on a small boat, we were driven to give the socks a decent burial at sea – but not before solemnly thanking their unknown donor.

The house in Battersea had not always been a convent. After we moved in, I was sent the original title deeds, dated 1871, which were no longer required by the Land Registry

since they were of pre-registration dates. The documents, which are colourful, embossed with sealing wax and tied with silk ribbons, record a great deal about the people who were once involved with the property. For example, they show that the freehold of the house, stables and coach house had originally been sold to Dr Augustus Phillips Hills by the Commissioners of Her Majesty's Works and Public Buildings (acting in execution of the Battersea Park Acts) for the sum of £232 in 1897.

In those days the name and address of the house was Elstree House, Bridge Road, Battersea, Surrey. The house next door, where Dr Hills had his surgery, was known as Carlton House (as it still is).

Elstree House had a frontage of 41.8 feet, rather smaller than the Carlton House frontage of 73 feet. In 1911 the London County Council, under compulsory powers, took a strip of land 6ft wide from the front of Elstree House for the purpose of widening the road. Carlton House, whilst next door to Elstree House, escaped this outrage since its land was around the corner in Prince of Wales Drive.

By the time I purchased Elstree House a hundred years later, its fortunes had been in a downward spiral for a good many years and it needed a great deal of money to return the house to its former glory.

There stood outside, at the back of the house, a 10ft-high statue of the Virgin Mary on top of a vast concrete plinth which dominated the whole garden area and had obviously been used by the nuns as a shrine. We wrote to the order of

nuns asking if they would like to have their effigy back, but they refused, saying 'We no longer want it, dispose of it as you wish.' To me this meant breaking it up and putting it in the skip and I instructed the builders to do just that, but here was the interesting thing: I could not get them to do it. In vain did I explain that it was just a concrete and plaster monument that was no longer needed by the people who had created it, but this 'macho' team hung back, afraid to strike a blow at what they saw was an image of 'Our Lady' and worried that bad things would befall them if they did.

In the end, I resolved the problem by donating the statue to a firm in Kent who removed it from its plinth, after which the builders were happy to break up the remaining concrete, and the plans for the garden redesign could be put in hand.

It was an extremely rewarding refurbishment project and it was interesting to live in the house, now carefully restored to its original use. However, all this might make boring reading if it did not have an interesting sequel.

During the summer of 2008 I attended a lecture at a writers' club in Hampshire, where I met a nun called Marion Dante who had written an autobiography in 2007 called *Dropping the Habit*. She had a copy of the book with her and I took it home to read. Like many people I opened the back of the book first and on the final page my eye was arrested by her signature and date. 'Marion Dante. On the Feast of Saint John Bosco, 31 January 2007.'

Saint John Bosco. How strange! Might Elstree House,

renamed by us as the Old Nunnery, be the Battersea community house where this lady, in her previous life as a nun, had lived? I read the book with new interest. Not only was she a nun of the same order, but she had stayed at Elstree House on many occasions as her best friend, Maeve, had spent a great deal of her life there while working at the nearby Battersea Youth Club.

Moving On

We sold the Old Nunnery in 1996 and moved to 17 Hyde Park Gate where we had a flat overlooking Sir Winston and Lady Churchill's old home. One of the good things about Hyde Park Gate was the dual entrances. We could drive our car out from the underground parking and straight down the mews at the back of the building, thus avoiding the bottleneck often experienced at the entrance of Hyde Park Gate.

This benefit was invaluable when the crowds became so dense the next year (1997), following the death of Princess Diana, that it was virtually impossible to get out of the entrance to Hyde Park Gate for weeks.

As well as our move to Hyde Park Gate, 1996 was also the year that my father died. I rang his aunt, Cicely McCall, my great-aunt, to tell her. 'My father died last night,' I informed her on the morning of 21 June.

'Can't have,' she retorted, 'he is younger than I am.'

My great aunt Cicely was at that date a mere ninety-six years old and still living on her own at the End House in Norfolk. She had become, over many years, one of my closest friends and we had been through several adventures together in which, I may say, she was almost always the ringleader.

I count myself very fortunate to have had a great-aunt with whom I got on so well and there appeared to be no age gap at all. She had a total lack of self-regard, a generosity of spirit and was one of the funniest people I knew, with a great ability to see the ridiculous in almost any situation.

The year before my father died she had published a memoir, entitled *Looking Back at the Nineties*. It is the story of an exceptional woman. On an American Commonwealth Scholarship (the Americans were more advanced in these things than we were) Cicely qualified at the London School of Economics in 1935 as a psychiatric social worker. Thereafter, she worked in prisons, approved schools, child guidance, adult education, and mental hospitals.

At one point, she stood as a Labour candidate in a parliamentary election, much to the consternation of her family! In 1973 Cicely was awarded an MBE and for her work with MIND she was made one of their Vice Presidents.

Cicely was thrilled to be invited to join the procession of carriages for the 100th birthday parade of Her Majesty the Queen Mother in July 2000. It was a big ordeal for all the 100-year-olds and, as Cicely said afterwards, 'I think I wet

my knickers, but nobody noticed or cared!'

Right up until the end of her life she had an order of coffee sent each week from Fortnum & Mason in London, and this was hysterical because she did not have two beans to rub together. The coffee was ceremoniously sipped and enjoyed from a variety of broken or chipped cups, which had been grand once upon a time, and I think that the disparity was not lost on her. Her delight in this ritual was evident and only goes to show her style and panache.

She died in 2003 and I lost a good friend. We all did.

QUEEN ELIZABETH THE QUEEN MOTHER'S

100th BIRTHDAY

CEREMONIAL

for the

THANKSGIVING SERVICE
AT ST. PAUL'S CATHEDRAL

at 11.30 a.m.

Tuesday 11th July, 2000

The Linley Bureau

In 2001 I found myself outside David Linley's shop in Pimlico admiring a small bookcase that I could see in the window. I went into the shop to enquire its price and was told that it had already been sold. 'But', said the persuasive Hughie, 'we have a similar piece in our boardroom if Madam would care to take a look.'

Madam did care to take a look, but the piece was considerably larger than the one in the window. In fact, it was 10.3ft x 7ft large. The sale price offered was generous for a major piece of furniture, but it was still a fortune to me. I looked across at my husband, David, who had not wanted to be there in the first place and was busy examining a plant in an earthenware pot on the floor.

Normally I would have suggested time to think about the offer – certainly overnight, maybe a week, perhaps for

ever – especially as the bookcase was far bigger than I was looking for.

Just when I was about to open my mouth along these lines, a far more dominant voice took over. 'I'll take it,' I heard the Voice say. David fell into the potted plant he was examining. 'In fact,' the awful Voice went on, 'I'll take the lot, all twenty-two pieces of furniture in the boardroom.' The normally suave Hughie took a step backwards. 'But none of it is for sale,' he gasped. 'Seems a pity to split it up,' the Voice went on, 'everything matches the bookcase.' I cast a rapid look around the room to see where the Voice was coming from and concluded that it could only be coming from myself.

By now David Wingfield was extracting bits of broken pottery from his clothing. The financial department at Linley was consulted, prices were floated, senior members of staff were approached. The Voice made an offer. 'You haven't got the money,' hissed the husband. 'I know,' the Voice said, blithely, 'but I will have by Monday. I will take and pay for half the contents then; the boardroom table and chairs can wait until Christmas.'

'We will throw in the remains of the potted plant,' said Hughie, 'since a large amount already seems to be invested in you.' He removed a final shard from David's jacket and dusted him down. 'David Linley* will certainly want to meet you when he returns from France,' said Hughie. 'He likes to

* David Armstrong-Jones, 2nd Earl of Snowdon. Born 3rd November 1 1961. Styled as Viscount Linley until 2017 and known professionally as David Linley.

know who buys his furniture.' 'You bet your socks he does,' said the Voice, by now entirely unrecognisable as mine.

The practical points of how we were to physically house the contents of a boardroom 32ft long by 18ft wide with an 11ft high ceiling into our little flat with its 8ft 10 inches ceiling, already packed with furniture, seemed to have escaped my attention.

In the afternoon the Voice continued her high-risk shopping spree, finding the key to the nation's financial solution single-handedly. The same authoritative voice said, 'I'll take it' to the offer of an unseen flat in Manchester, a two-bedroomed flat on the 18th floor of a tower block in Canary Wharf, a studio flat in Battersea on which a mortgage would have been impossible and a £1.5 million house in Chelsea in which to put the Linley boardroom collection. Not bad for a day's work and all of this was totally out of character – or was it?

Fortunately, I went back to my normal self the next day and can offer no explanation for this extraordinary interlude of madness except to say that it was all worth it. Twenty years later I still have all the Linley furniture, which I love. My daughter has the Manchester flat. My son had the Battersea flat and the Canary Wharf flat sold on extremely well. The Chelsea house was the only purchase, on that mad day, not to complete.

We were obliged to wait some time before the bookcase could be removed from the Linley showroom. Westminster Council had to give permission for the road to be closed

and then the bookcase had to be winched out of the first-floor boardroom window.

By this time David Linley was back from France. He stood in the middle of the closed road and gazed up at the first-floor window where the bookcase was by now jammed in the window space. 'Well', he said, 'it came in that way, so it has to get out the same way.' Of course, he was right but, as Pooh Bear discovered when he visited Owl's home in the tree, it is far easier to climb into a small gap than it is to climb out of it.

The Linley bookcase broke into four sections but it still took four strong men to carry the main body of the piece and it did not escape my notice that as the bookcase was lifted off the floor there was a large hole at one end where the floorboards no longer joined the wall. It would need a good deal of repair if the board of directors were not to fall through the floor and join the customers in the showroom below. Just saying.

The Ginger Cat

On Tuesday, 3 December 2019 I woke with no voice and a throat so sore it was like swallowing razor blades. I hosted a lunch at Fiume, talking only in a whisper. The next morning I was no better but, dosed on paracetamol, got through a busy day, hosting a lunch at the flat. Thursday, I felt awful but my voice had returned so I thought the paracetamols were working. On Friday, we were booked to meet Ione and Nick for lunch at Stockbridge to exchange Christmas presents and we drove Charlie down, too, so that he could see them. Fortunately, David drove but I had to drive to Salisbury afterwards to put Charlie on a train to London because David had had wine for lunch and I had not. We then went on to Nadder Barn where I concentrated on getting better. I did not get better, in fact I got worse and was running a high temperature which all the paracetamols in the world were not reducing.

On Tuesday, 10 December we left Nadder at about 11:30am and should have gone straight to our doctor's clinic in Sloane Street. Instead, we went back to the flat which was warm and comforting, what I thought I needed. Big mistake! By 7pm I was feeling awful and, dare I say it, frightened. Thank God for Dee. He rang the surgery and got the out-of-hours team who came to visit in the form of a kind doctor at about 9:30pm. Seems that I have got pneumonia. Worse, I have a terrible pain in my right lung every time I take a breath. 'I am on it,' she said, as she massaged my back where the pain was.

She took some blood and put me immediately on antibiotics and doubled the dose of paracetamol. She tells me that I might have to have an 'ivy shot' tomorrow, in hospital, which could be interesting.

Thank God I got some sleep, none the night before. I also dreamt … and I never dream, ever. This one came in the form of a ginger cat, of superior size, which made two attempts to bite me. It had vicious teeth and the third time it came at me I got it round the neck and squeezed and squeezed. I remember thinking that I could feel every iron sinew in its throat, but I hung on and knew that I must not give up. The revolting creature spewed out an orange liquid all over my bed and bed sheet, but I clung on until it lay dead. Then I rolled all the linen and the dead creature into a ball and put it into the dustbin.

P.S. Charlie thinks that an 'ivy shot' is not, in fact, some

species of Christmas cocktail, but rather an intravenous drip
... surely not!
By now, Wednesday, 11 December, I am on the antibiotics
(Augmentin), which I am taking every eight hours with the
paracetamol. I have twenty-one tablets but that is not going
to be enough to kill this bug and we have to supplement it
with three days of Azithromycin. At 9.30am on Friday, 13
December I see the breathing specialist at the Cromwell
hospital who takes his own blood samples and gives me a
chest X-ray. He tells me that my lungs are abnormal. 'Why?'
I ask.

'Because they do not inflate properly,' he says.

I do not know about that: I seem to get enough air to stay
alive, one way or another, but I say nothing.

Eventually, he lets me go. Tells me that he is going to
give me the benefit of the doubt but wants me to see him
again on the 16th and the 19th. Phew! By the time I see him
again on the 16th I am already miles better but I fail his
breathing test and can't catch my breath. I tell him that I
do not understand why I have pneumonia when I have been
vaccinated five years previously. He tells me that I have only
been vaccinated against streptococcus pneumonia, not all
the other strains of pneumonia. Strange to me. I did not
know that there were several variants.

I ask him on the 19th whether this bug is now dead, and
he reassures me that it is. I tell him that whatever this bug
is, it is a very vicious one and he agrees, and I get to go
home for Christmas.

As always with my stories there comes a sequel. After the New Year I went back to work as normal, particularly because Matt's father had died at Christmas and he was in Australia for a month looking after his mother and family affairs. I also went back to my Pilates classes, but that had a devastating effect on my shortness of breath and some exercises made me cough. I had persevered because the breathing man told me I must practise Pilates at least twice a week.

On 23 January I saw the breathing man again (my fourth visit), who signed me off as fit. Matt had developed a terrible cold, presumably caught from the aeroplane trip back from Australia the previous weekend. David went to Nadder Barn the following day, on his own, and I spent the weekend in London.

It was on the Saturday afternoon when I began to feel quite unwell with the sudden onset of a vicious sore throat. While I was eating a chocolate, it caught in my throat and I could not breathe. I staggered into the long corridor, struggling for breath and ran towards reception for help. It is a long corridor and, luckily, I found a gulp of air just before I reached the door to reception.

I had given myself a terrible shock so could not sleep that night and the awful throat persisted. I also had a temperature but nothing, I thought, to be concerned about. By Monday I was back at the surgery. This time I was not going to wait to see if this bug cleared up or not and sensibly the doctor prescribed another course of Azithromycin. Thank goodness

he did. Whatever I had cleared up after seven days and I was back at work.

By 27 January 2020 coronavirus or Covid-19 had not been mentioned by any of the medics that I saw, and I just had a 'bug' ... or did I? I think that I had a very narrow escape from a Covid-related illness. Oh, and I also think that you can indeed get a Corona-related virus twice. I did.

If it was Corona virus then I can attest that it does, indeed, leave some aftermath. My body was wracked with pain for weeks afterwards. Not just the joints but the muscles in the legs, arms, neck, back, thighs and shoulders. Sleep was very deprived. Also, if I overdid physical effort then I became short of breath and I coughed a lot. A sip of alcohol had the same devastating effect and I struggled to breathe. Quite scary but, apart from all of that, four months on I am fine but wary! In my experience the coughing comes after the infection has struck, not before.

Summing Up

Despite my boss at Barratt Developments telling me years ago that I should never assume anything in life it seems reasonable to suppose that, at the age of eighty-three, I must be nearing the end of my life – hence this memoir. Has it been a good life? Well, it has been up and down like anybody else's but by far and away the best things have been my children, my grandchildren and my third husband, David, who deserves a long-service medal, with two bars, for staying the course. Come to think of it, maybe it is me who deserves the medal.

Yes, I forgot to mention that I worked for Barratt Developments, who taught me a great deal of what I know about property, but I forgot to mention all sorts of other things as well, which will just have to wait until I produce a second volume when I am a hundred. After all, anything is possible!

Acknowledgements

Thank you: Alice, Matt, my husband David, Emily and Charles, and to Sam Carter.

Index